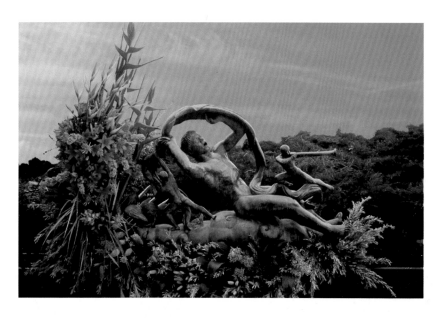

ART IN BLOOM

FIRST EDITION

99 98 97 6 5 4 3 2 1

This is a Deseret Equity, Publishing Division book

P.O. Box 17734

Salt Lake City, UT 84117

Book designed by Lezlie Sokolik

Edited by Caroll McKanna Shreeve

Typeset in the United States of America

Photography art directed by Sjur Fedje

Reproductions by Nordvest Repro AS, Molde, Norway

Printed by Hatlehols Trykkeri AS, Brattvåg, Norway

Printed on Euro Art Matt 150g/m TCF (Chlorine free)

Bound by K. Johnsen Grafiske Senter AS, Skien Norway

Library of Congress Catalogue Card Number: 96-093122

Ream, Victoria Jane

Art in Bloom: a new art form combining painting and

sculpture with floral design / written by Victoria Jane Ream ;

photography by Sjur Fedje.

p. cm.

Includes bibliographical references and index

ISBN 0-9655928-0-4

MUSEUMS HOSTING ART IN BLOOM EVENTS

Asian Art Museum of San Francisco
San Francisco, California

Birmingham Museum of Art
Birmingham, Alabama

**Denver Art Museum and
Denver Botanic Gardens**
Denver, Colorado

Detroit Institute of Arts
Detroit, Michigan

**Memorial Art Gallery of
the University of Rochester**
Rochester, New York

M.H. de Young Memorial Museum
San Francisco, California

Milwaukee Art Museum
Milwaukee, Wisconsin

Minneapolis Institute of Arts
Minneapolis, Minnesota

Museum of Fine Arts, Boston
Boston, Massachusetts

Museum of Fine Arts, Houston
Houston, Texas

New Orleans Museum of Art
New Orleans, Louisiana

San Diego Museum of Art
San Diego, California

Santa Barbara Museum of Art
Santa Barbara, California

**University of Pennsylvania
Museum of Archaeology and Anthropology**
Philadelphia, Pennsylvania

University of Utah Museum of Fine Arts
Salt Lake City, Utah

Virginia Museum of Fine Arts
Richmond, Virginia

Wadsworth Atheneum
Hartford, Connecticut

Walters Art Gallery
Baltimore, Maryland

Talbot, Mrs. Peter S.
Santa Fe Garden Club, Zone XII, New Mexico

Taylor, Sandy
Garden Club of New Haven, Connecticut,
Nantucket Garden Club, Massachusetts

Thomas, Penny
Garden Club of Princeton, Pennsylvania

Thomson, Mrs. Alexander, Jr.
Garden Club of Denver, Colorado

Tyler, Carol
Flower Guild, The Church of Saint Martin's-in-the-Fields ,
Pennsylvania

Walker, Carol Ivy
River Oaks Garden Club, Texas

Walters, Ms. Cen
Midlothian Garden Club, Virginia

Warfield, Barbara
Howard County Garden Club, FGC, Maryland

Welton, Mrs. Richard, IV
Virginia Beach Garden Club, Virginia

West, Paula
Cattail River Garden Club, FGC, Maryland

Wilkinson, Mrs. Judith
Newburyport Garden Club, Massachusetts

Wilson, Marilyn
Garden Club of Denver, Zone XII, Colorado

Zissler, Alice
Cloverdale Garden Club, New York

FLORAL AND INTERIOR DESIGNERS

Andrews, Don
Burnsville, Michigan

Atkinson, Barbara
Plan Decor, Burlingame, California

Baba, Karen
Plan Decor, Burlingame, California

*Baddeley, Gayl
A.S.I.D., Gayl Baddeley Associates, Salt Lake City, Utah

Banting, Donna
The Garden Gallery, New Orleans, Louisianna

Barlass, Donna
Washington County Horticultural Society, Minnesota

Barrett, Diane
M.H. de Young Museum Society Flower Committee,
San Francisco, California

Bergner, Sarah
Sarah Bergner Design, Houston, Texas

Bishop, Brittany
Babooshka, Houston, Texas

Blach, Cathy
Jasmine Flowerwork, Birmingham, Alabama

Braun, Ary
AIFD, Golden Iris Florist, California

Brown, David
David Brown Flowers, Houston, Texas

Cain, John
Babooshka, Houston, Texas

Calhoun, Terry
Nob Hill Florist, San Francisco, California

Campbell, Benny
Attalla Florist, Gadsden, Alabama

Culver, Marty
Jasmine Flowerwork, Birmingham, Alabama

Deatherage, Kathleen
S. R. Hogue & Company, Santa Barbara, California

Dotti, Nancy
Through the Garden Gate, Santa Rosa,California

Evans, Rich
Boulevard Gardens and Floral, Minneapolis, Minnesota

Gallucci, Joan
Comina, Inc., Connecticut

Garner, Regina
Gina's Extravagant Flowers, Salt Lake City, Utah

Gazebo Plants and Flowers
Santa Barbara, California

Gore, Mary Lou
Comina, Inc., Connecticut

Hart, Bonnie
M.H. de Young Museum Society Flower Committee
San Francisco,California

Hogue, Scott
S. R. Hogue & Company, Santa Barbara, California

*Horne, Colleen
Andover Interior Design West, Salt Lake City, Utah

Huhner, Joseph P.
Nosegay Florist, Metairie, Louisiana

Kaufmann, Mary
Haddam, Connecticut

McFarland, Rob. W.
Ward and Child—The Garden Store, Salt Lake City, Utah

McGhie, Kristine
Floral Designer, Salt Lake City, Utah

Michel, John,
John Michel Design, Palm Springs, California

*Miller, George P.
Crawford and Day Fine Furniture, Salt Lake City, Utah

Money-Collins, Holly, *AIFD*
City College of San Francisco, California

*Morgan, Ron
Ron Morgan Designs, Oakland, California

Moss, Dee
*M.H. de Young Museum Society Flower Committee
San Francisco, California*

Patterson, Jane
Santa Barbara Museum of Art, California

Pavel, Kimberly
San Diego, California

Peddicord, Jerry
S. R. Hogue & Company, Santa Barbara, California

Quiros, Lyna
Seiferts Floral Co.,Walnut Creek, California

Ream, Victoria Jane
Salt Lake City, Utah

Ruisinger, Mark
Galloway Florist, Inc., Houston, Texas

Samilson, Marge
*M.H. de Young Museum Society Flower Committee
San Francisco,California*

Shaw, Dorothea, B.
Hartford, Connecticut

Shipley School Fifth Grade &
Upper School Students
Pennsylvania

Soniat, Paul, Director
New Orleans Botanical Garden, New Orleans, Louisianna

Stanger, Jerry
Ward and Child—The Garden Store, Salt Lake City, Utah

Sylvester, Sybil
Wildflower, Birmingham, Alabama

Thomas, Lisa
Blossom's Flowers, Santa Barbara, California

Verhey, Nancy
Nancy Verhey Designs, Mill Valley, California

Wasson, Pat
*Detroit Institute of Arts, Detroit, Michigan
Art & Flowers Chairman 1993*

Wirfel, Bobb
In Bloom, Inc., Houston, Texas

Wright, Holly Clark
Floral Designer, Salt Lake City, Utah

Yates, Marilyn Allen
Hartford, Connecticut

* Offering interior and
 floral design services

*To my remarkable mother
in her quest for excellence.*

ART IN BLOOM

BY VICTORIA JANE REAM

Photography by Sjur Fedje

CONTENTS

FOREWORD

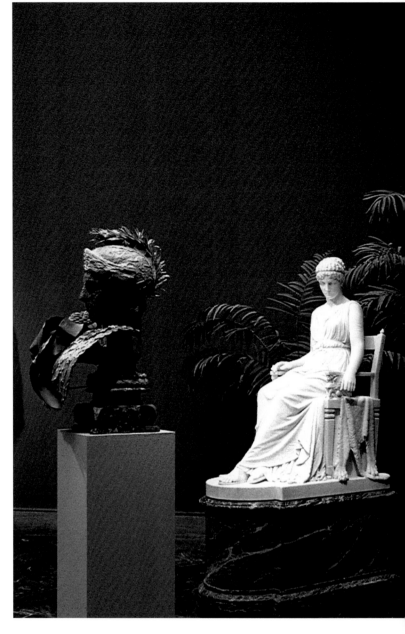

Whether the museum event is called *Art In Bloom, Art Alive!*, or *Bouquets To Art,* the same wonderful theme is carried throughout the exhibit as flowers are combined with magnificent works of art. The quality of floral works complementing the art is surprisingly consistent for visitors who make the transition from one hosting museum to the next. I believe that flower arranging is truly an art and that the museum setting provides a great showcase for the floral art's many nuances of style and imaginative interpretation.

Presenting lectures in the same museum on several occasions has given me an opportunity to see how the same work of art is interpreted by different floral designers over several events in successive years. Flower arranging experts have their own aesthetic eye. They see in a work of art what appeals to them and then integrate those perceptions and feelings into the arrangements they create.

It is interesting to see the cooperation between florists and garden club arrangers who approach the *Art In Bloom* project with equal zeal. Different materials available in growing regions during different seasons around the country make possible–and often necessary–great creative ingenuity and variety in the arrangements seen from museum to museum. We on the West Coast have so much to choose from when it comes to botanical materials, it is no wonder that floral arrangements created in our region are often larger and more lush than those of some other areas of the nation.

The crowds of people who attend *Art In Bloom* events often wonder what a particular arrangement has to do with the painting or sculpture it is designed to interpret. We are slowly educating members of the public to have more discerning eyes and open minds when they view these exhibits, seeking to understand the finer points of symbolic interpretation rather than literal copying of the art with flowers. It is wonderful when people who revisit a painting or sculpture see it in an entirely new light with deeper values once the interpretive floral arrangement is in place. One of the joys of participating in these events is to stand back and listen to the comments of these visitors. I'm not certain how

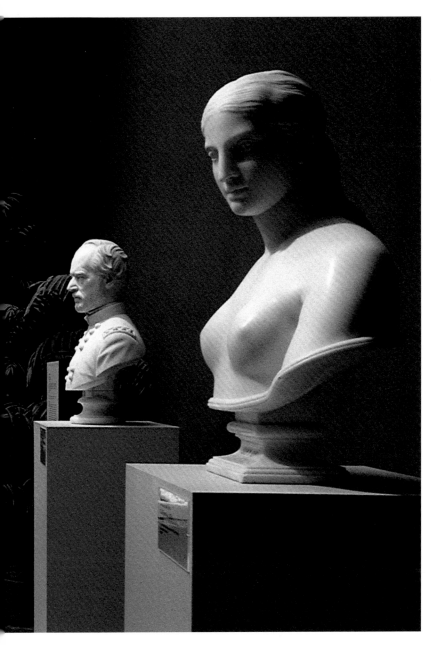

Ron Morgan

Recognized internationally as an outstanding floral designer, he possesses a unique talent for turning the ordinary into the exquisite through his use of an unusual variety of plant materials artfully combined in extraordinary containers. The most sought-after floral designer in America, his popular lectures and demonstrations explore the hows and whys of flower arranging. The award-winning Morgan's philosophy is: "Flower arranging is supposed to be fun. Once it gets to be a hassle, give it up!"

He is a founding member of the elite American Institute of Floral Designers. Schooled in the fine arts, a subject he taught before venturing into floral design, he uses his extensive knowledge of art, antiques, and collectibles and his inherent instinct for what works beautifully together to create unusual furniture and decorator items. His hand-painted furniture and screens are works of art and his faux finishes are often indistinguishable from "real" surfaces. He recently completed a radio and television lecture tour in London, England.

M.H. de Young Memorial Museum
Sculptured floral bust of man by
Ron Morgan

many museums are planning events this year for *Art In Bloom*, but the number grows every season and brings people who love flowers to the museums who might not otherwise have ever visited one.

Art In Bloom is such a great marriage of the arts where people experience painting, sculpture, and flower arranging all in one place. What a tribute to this event Victoria Jane Ream's book is and what a service she fulfills in encouraging readers to create *Art In Bloom* in their own homes. —*Ron Morgan*

ACKNOWLEDGMENTS

The origins of this book, *Art In Bloom*, stem from my life-long interest in art and flowers. My professors of art history at Wellesley College introduced me to the aesthetic pleasures of fine art that have continued to expand through extensive world-wide travels. As an avid gardener and floral designer, I continually marvel at the beauty and variety of nature. The concept of combining art and flowers as a unified expression has fascinated me since my first exposure to *Art In Bloom*. Having served on committees producing *Art In Bloom* at the University of Utah Museum of Fine Arts and having come to realize that this subject had never been studied at the national level, pursuing such a challenging project excited me. After contacting several museums across the nation whose directing staff expressed interest in participating in such a study, the project began to take shape as an illustrated book.

On presenting the idea to museum photographer and conservator Sjur Fedje of Norway who had extensive experience with museum work throughout Europe, he looked at me seriously and said, "That will entail a great deal of work." In my naive enthusiasm, I responded, "Oh, that's all right." Now, more than two years later, I am even more enthusiastic about *Art In Bloom*, but wiser about the work involved and the hundreds of people who were needed to help produce this book. My greatest appreciation goes to Sjur who crisscrossed the country with me numerous times to photograph the exhibits over a one-year period, gracefully accepting the constraints of museum and *Art In Bloom* schedules. His technical and artistic skills in visually capturing the beauty of both the art and floral design made this book possible.

My thanks to early mentors in ten years of medical research publishing who helped me gain the necessary organizational skills and focus to complete a work of such magnitude as *Art In Bloom*, Stanford Wessler, M.D., Duncan P. Thomas, M.D,. Ph.D., and Stanley M. Reimer, Ph.D.

To the founders of *Art In Bloom* in 1975, Charles (Chuck) Thomas and Barbara Mustard at the Museum of Fine Arts, Boston, I offer my applause and gratitude.

A special thanks to my friend, Ron Morgan, an internationally recognized floral designer, teacher, and *Art In Bloom* specialist who answered my thousand questions and graciously wrote the foreword to this book.

I am greatly indebted to E. Frank Sanguinetti, Director of the University of Utah Museum of Fine Arts, whose interest, advice and encouragement kept me "on task" as the enormity of the project evolved.

I am most grateful to the directors and numerous museum personnel in public relations, photography, conservation, rights and reproduction, and special events at each of the 18 museums listed on page iii who allowed Sjur Fedje and I to photograph and conduct interviews at the exhibits on location.

A very special thanks goes to Jean Palmer, Chairman, Museum Society Auxiliary at the M.H. de Young Memorial Museum; to Sari B. Klok, Special Events Manager at the Detroit Institute of Arts; to Margaret Kessels, Development Associate for Fund Raising Activities from the New Orleans Museum of Art; Carol Tillman, Coordinator, Friends of the Institute of the Minneapolis Institute of Arts; Misty Moye, Office of Rights and Reproduction at the Museum of Fine Arts, Houston; Pam Kosty, Public Information Officer and Ann Butcher from the

University of Pennsylvania Museum of Archaeology and Anthropology; Mardi Snow, Public Relations Manager, Marilyn Sedlock, Special Events Liaison and David L. Kencik, Administrative Assistant, Collections and Rights and Reproduction at the San Diego Museum of Art; Suzanne Hall, Manager, Marketing and Public Affairs at the Virginia Museum of Fine Arts; Barbara Luton, Director and Virginia Cochran, Public Relations Director of the Santa Barbara Museum of Art; Monique Shira, Public Relations Officer, Mark Zurolo, Photographic Department, Helen Perry and Susan Fellingham, Co-chairman of Fine Arts and Flowers from the Wadsworth Atheneum; and Beth Blasser Dietric, Media Relations Coordinator, Betsy Bond, Museum Coordinator and Terry Ulmer, Chairman of *Art Blooms at the Walters* Art Gallery.

Two museums that did not hold their *Art In Bloom* events during the year we photographed and prepared descriptions of exhibits, made special arrangements to produce exhibits specifically for the purposes of this book. For the effort required to organize and arrange the set ups comparable to the exhibits photographed at other aforementioned museums, my thanks to Charlotte Herrera, President of The Council and Joan Baden from the Memorial Art Gallery of the University of Rochester. The director of the University of Utah Museum of Fine Arts, E. Frank Sanguinetti, and William Balken, Director of Development allowed us the use of their museum facility and met every request for assistance.

To all of the garden clubs and many floral and interior designers listed on pages *iv - vii* who are the creators of the *Art In Bloom* exhibits, I marvel at your creativity and comprehension of the subject. I appreciate your discussions with me at the museums, by letter, and on the phone.

To the many hundreds of community volunteers across the nation who produce these extraordinary *Art In Bloom* events, you bring beauty to your communities, a larger public exposure to your museums, and needed funding for museum programs.

To W. Richard Hildreth, Director of Education at Red Butte Garden and Arboretum at the University of Utah, my appreciation for providing the botanical names. Professional floral designers have a taxonomic nomenclature, at least with common names for plants, that is unique and colorful but works for them. Our challenge was to come up with a correct botanical name for the broad spectrum of the plant world represented in the arrangements. Photographs of the arrangements or lists supplied by the floral designer, were used for identification. The basis for most of the nomenclature was *Hortus III, A Concise Dictionary of Plants Cultivated in the United States and Canada*, 1976, by the Staff of the L.H. Bailey Hortorium, Cornell University, Macmillan Publishing Company.

On a personal level, cheers to my four children, Rebecca, Rachel, John, and Victor who patiently endured two years of an often absentee mother, while I was on an airplane, at a museum, on the phone, or at my computer. Thanks as well to my supportive extended family.

To my dear friend Colleen Horne, whose continuous enthusiasm, advice during the "sticky" problems and expert design help kept me pursuing the degree of excellence, breadth, and depth due the *Art In Bloom* museum art form, a huge thank you.

And finally, to Caroll McKanna Shreeve, my encouraging and skilled editor, and her associate creative designer, Lezlie Sokolik—my gratitude for helping make this book a reality almost equal to visiting an *Art In Bloom* museum event.

PART ONE
CREATING A NEW ART FORM

CHAPTER ONE
Art In Bloom
AN INTRODUCTION

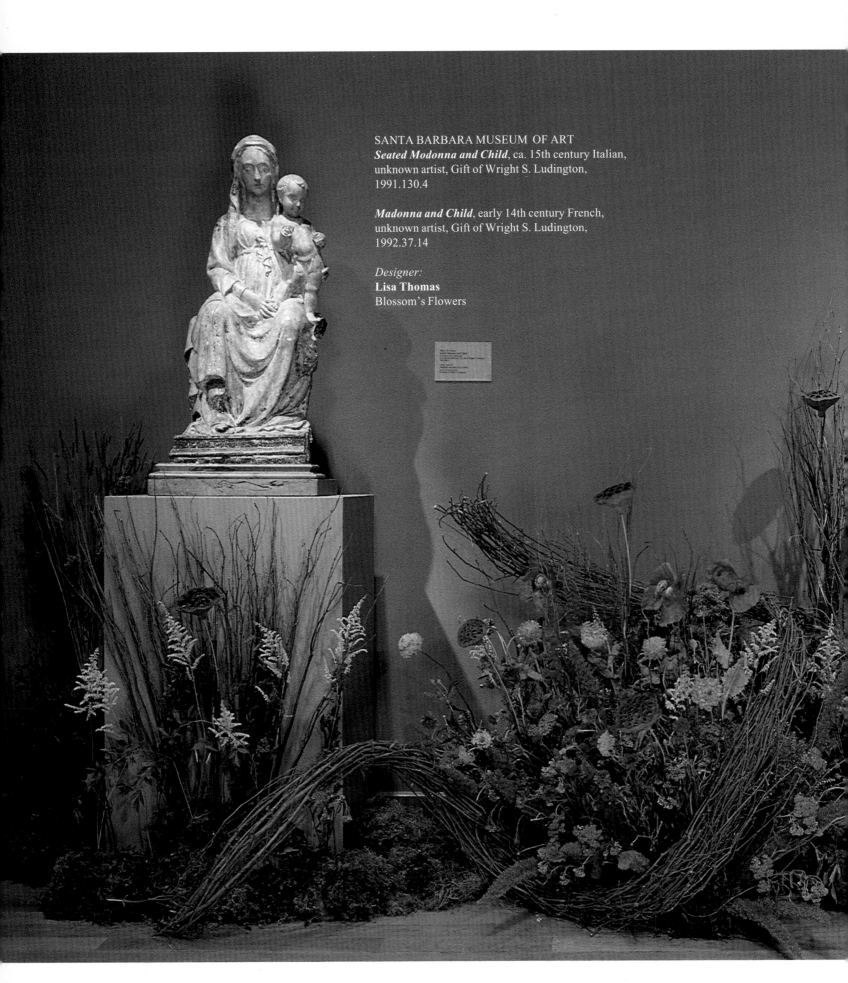

SANTA BARBARA MUSEUM OF ART
Seated Modonna and Child, ca. 15th century Italian,
unknown artist, Gift of Wright S. Ludington,
1991.130.4

Madonna and Child, early 14th century French,
unknown artist, Gift of Wright S. Ludington,
1992.37.14

Designer:
Lisa Thomas
Blossom's Flowers

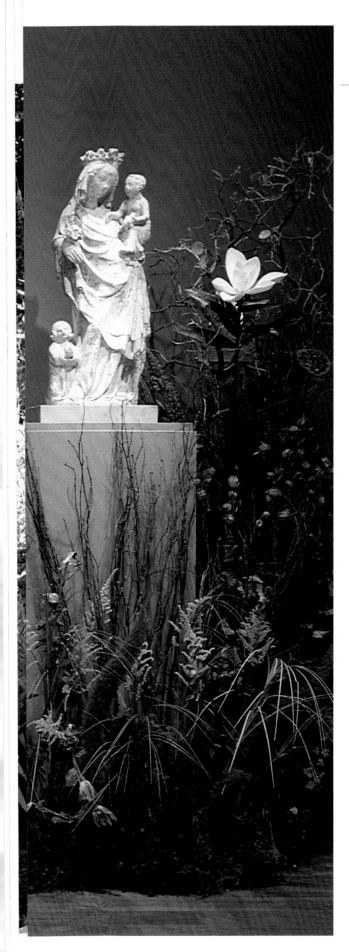

In museums across America, a celebration of fine art and flowers has become a festive and exciting annual event. A visual feast is created when exquisite floral design interprets and enhances a painting, sculpture, or other work of art. Called *Art In Bloom* by the Museum of Fine Arts, Boston who initiated the event, it has been successfully adapted by museums nationwide. The event names vary; *Art In Bloom, Flowers & Art, Art En Fleurs, Bouquets To Art, Art Blooms at The Walters, Fine Art & Flowers, Art In Bloom–A Festival of Spring, Art Alive!* and *ARTifacts IN BLOOM*. This event is so well received that each year the number of people attending and the list of participating museums grows.

What is *Art In Bloom* and how did it begin?

Art In Bloom, first conceived by Charles (Chuck) Thomas at the Museum of Fine Arts, Boston, was an idea to encourage museum attendance in the early spring. The sun's warmth after long winters and home gardens needing to be planted were often more enticing than indoor museum activities. The idea of combining the beauty of spring flowers with fine art in the museum occurred to him as a creative event with great potential for a broad audience. By inviting garden clubs to participate, he imagined the museum's exposure would expand. It was a dynamic idea that was quickly accepted by lovers of art and flowers.

The first *Art In Bloom* held in Boston in 1976 was directed by Barbara Mustard. Twelve floral arrangers from the museum's Ladies Committee and six garden club participants were asked to interpret 18 paintings with floral design. Within five years, *Art In Bloom* was well established at the Museum of Fine Arts, Boston. Today, the four-day event attracts 20,000 visitors from all over New England. A major fund-raising event, the *Art In Bloom* concept has spread to museums all across the country.

CHAPTER TWO
Ancient Art

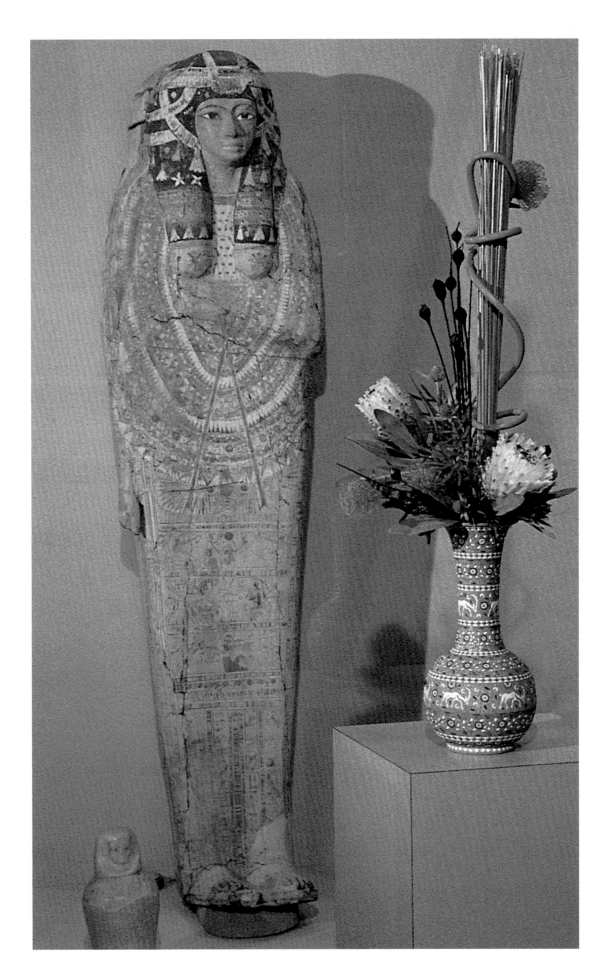

MUMMY CASE

DETROIT INSTITUTE OF ARTS
Mummy Case of an Unknown Woman
Egyptian, Early Dynasty XXII
1950-850 B.C.
Painted wood
Frederick Stanton Collection
11799

Floral Design:
Marge McGoff
Williamston Red Cedar Garden Club

Materials:
Pincushion Protea
Ranaunculus Reed, Ting Ting
Galls
Protea *Protea sp.*
Ranunculus *Ranunculus asiaticus*

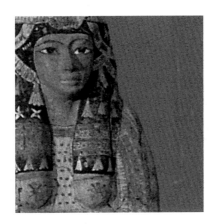

Made of wood and painted, the mummy case illustrates the attempt on the part of the ancient Egyptians to represent the deceased on the cover of the mummy.

DESIGNER'S COMMENTARY: The ancient use of flowers became and remained highly stylized, symmetrical, and rigid in design. . . . Therefore, a simple approach has been incorporated as dictated by the shape and theme of the container while maintaining the simple order and a feeling of geometric regularity as in the mummy coverings. The use of protea suggests an ancient Egyptian flower—the water lily. The reeds (Ting Ting) relate to the marsh grasses of that time.

MUMMY MASK

MUSEUM OF FINE ARTS, BOSTON
Mummy Mask
1st century, A.D. Egyptian,
Early Roman Period
Gilded, painted cartonnage, inlaid glass
Gift of Lucian Viola, Horace and Florence Mayer
Fund, Helen and Alice Colburn Fund,
Marilyn M. Simpson Fund, William Francis
Warden Fund, William Stevensen Smith Fund
1993.555

Floral Design:
Arranger: **Judith Wilkinson**
Assistant: **Lee Rowan**
Newburyport Garden Club

Materials:

Olive	*Olea europaea*
Foxtail Lily	*Eremurus sp. cv.*
Pink Mink Protea	*Protea x cv.*
Protea	*Protea sp.*

This richly decorated mask is ornamented with gold leaf, inlaid glass eyes, and intricate polychrome painting. The scene depicted on the bottom of the apron shows the god Orisis lying on an embalming table and flanked by the mourning goddesses Isis and Nepthys. Around the hood at the back of the head are depictions of the deceased and the gods of the Next World.

Museum Wall Text

DESIGNER'S INTERVIEW: In studying their assigned work of art, *Mummy Mask* from the museum's Egyptian collection, designers Wilkinson and Rowan realized that their floral interpretation would need both color and drama to stand out against the dark room. The mask itself contained metallic gold and terra cotta with umber tones and turquoise blue. They first searched for an appropriate container which was porcelain with gold leaf, one that had a similar confirmation to the mask and was large enough to accommodate a good-sized floral arrangement. Their selection of floral materials played off the colors and textures of the work of art, rather than represented materials from the Egyptian period. Olive branches with hanging olives, dark red lilies, and Italian poppies were used to pick up the colors of the headpiece and front panel.

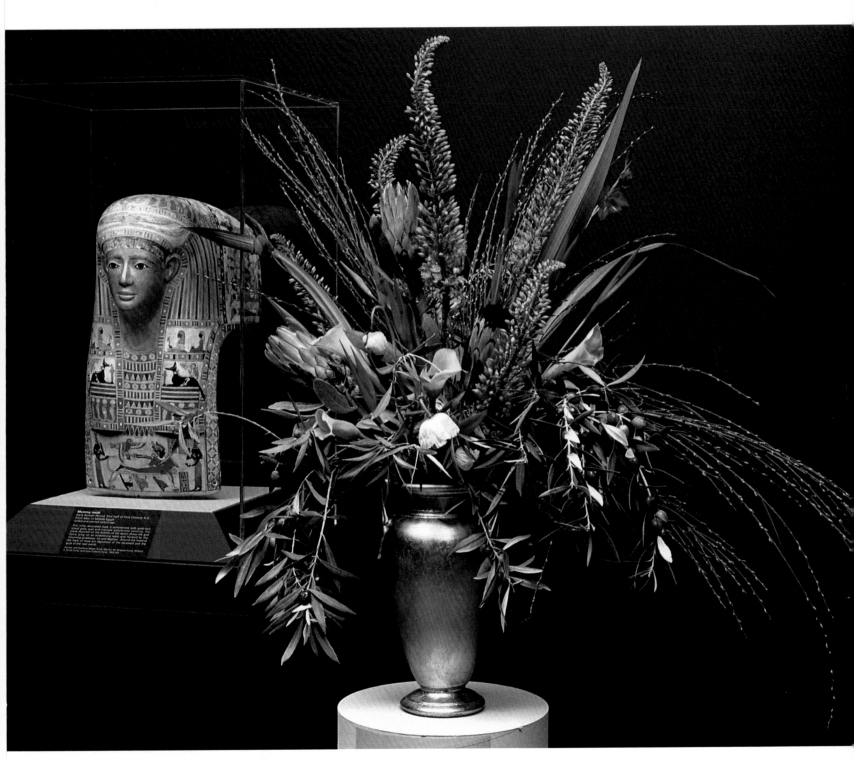

Photography Courtesy of Museum of Fine Arts, Boston

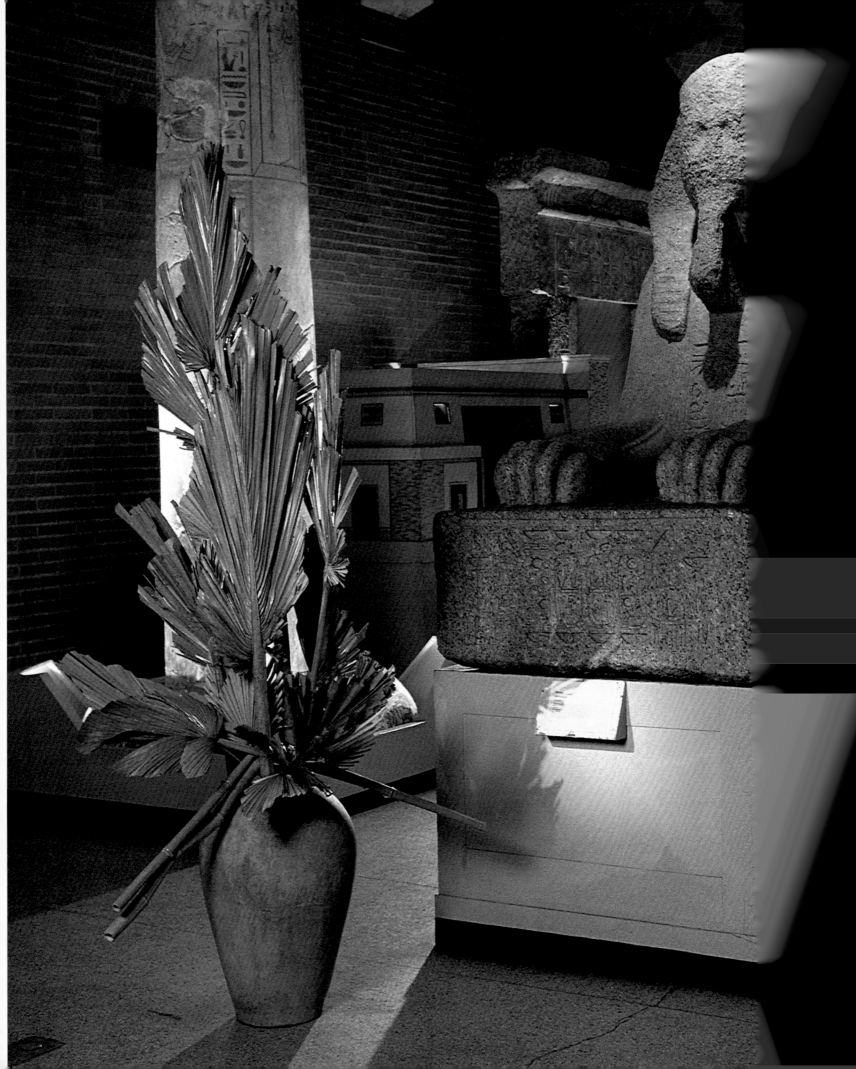

SPHINX

UNIVERSITY OF PENNSYLVANIA MUSEUM
OF ARCHAEOLOGY AND ANTHROPOLOGY
Sphinx
Egypt Memphis ca. 1290-1224 B.C.
Red Granite
No E-12326

Floral Design:
Pinkie Roe
Wilmington Garden Club

Materials:
Palm *Arecaceae*
Bamboo *Bambusaceae*

The sphinx, a lion with a human head, represents the power of the Egyptian king. This statue was buried up to its shoulders; only the exposed head was attacked by the windblown sand, which eroded the facial features and the royal false beard. The inscriptions on the chest and around the base give the five names of Ramses II.

His son and successor, Merenptah (1224-1214 B.C.), added his own cartouches to the shoulders after his father's death. This sphinx, one of the largest known, weighs about twelve tons. It was quarried at Aswan and transported by river to the Ptah Temple at Memphis, 600 miles away.

Museum Wall Text

DESIGNER'S COMMENTARY: The muted color and formal shapes of clipped palm fronds give homage to the eternal and powerful symbol of the sphinx.

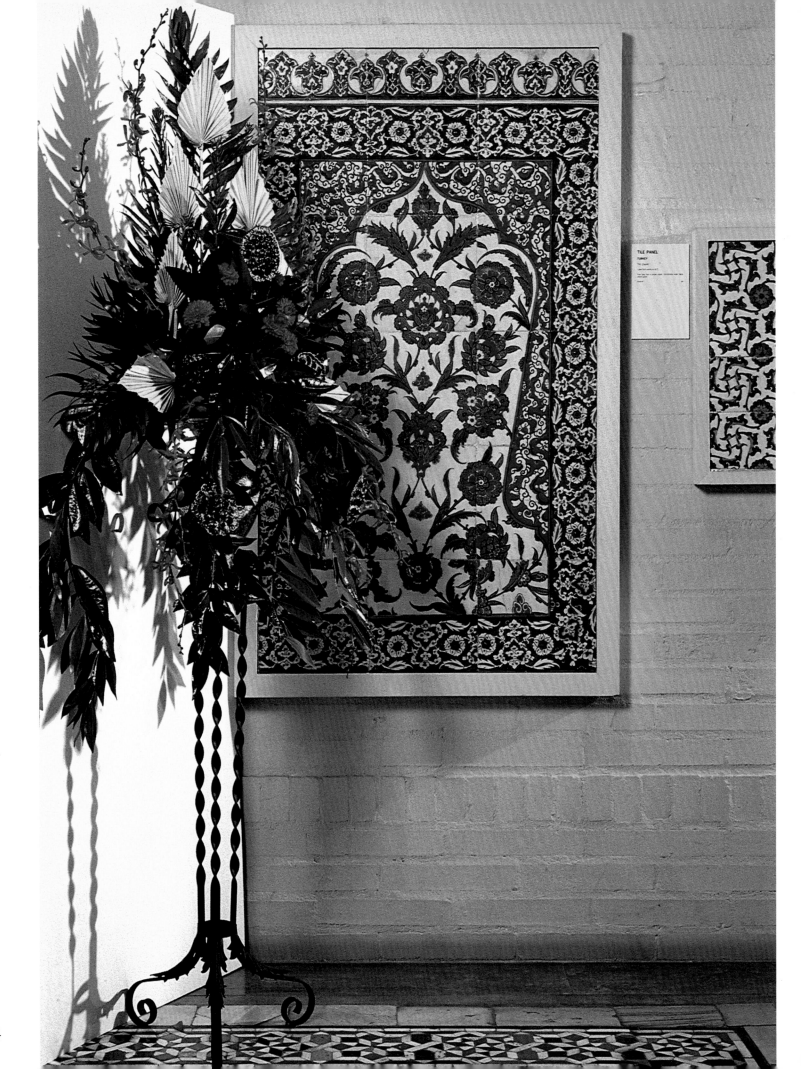

CERAMIC TILE

UNIVERSITY OF PENNSYLVANIA MUSEUM
OF ARCHAEOLOGY AND ANTHROPOLOGY
Glazed Polychrome Ceramic Tile Wall Panel
Turkey, Late 16th Century A.D.
Glazed Tile Panel
NE-P 59 Purchase

Floral Design:
Lori-Ann Eckert, **Carol Tyler**
Flower Guild, The Church of Saint Martin's-in-the-Field's

Materials:
Orchid X 'James Stori'	*Orchidaceae*
Chrysanthemum	*Chrysanthemum*
Palmetto	*Sabal sp.*
Pomegranate	*Punica granatum*
Lotus Pods	*Nelumbo nucifera*
Caculus	

Glazed Polychrome Ceramic Tile Wall Panel taken
from a mosque in Istanbul. Late sixteenth century A.D.
Panels of this kind covered walls, columns, and mihrabs
of many sixteenth and seventeenth century Ottoman
mosques. This type of decoration is known as Rhodian
or Iznik ware.

Museum Wall Text

DESIGNERS' COMMENTARY: Islam's art is characterized
by its decorative arabesques and all-over geometric
designs inspired by floral forms. Our arrangement
interprets this beautiful sixteenth century Turkish wall
tile in flowers and foliage contained within a specific
rectangular space mimicking the same sense of delight
in shape and color.

SPIRIT OF THE PLAINS

DENVER ART MUSEUM and
DENVER BOTANIC GARDENS
Spirit of the Plains: Six floral arrangements
circled the Indian tipi and warrior artifacts
in the North American Indian Gallery.
Some use of Colorado native plants was
encouraged.

Floral Design:
Elaine Jackson, Sandy Miller
Garden Club of Denver and Denver Botanic
Garden Guild

Materials:
Yellow Peruvian Lily	*Alstroemeria X aurantiaca*
Ravenna Grass	*Erianthus ravennae*
Canada Wild Rye	*Elymus canadensis var. glaucifolius*
Fennel	*Foeniculum vulgare*
Northern Sea Oats	*Chasmanthium latifolium*
Red Hot Poker	*Kniphofia uvaria*
Lily	*Lilium sp.*
Alpine Currant	*Ribes alpinum*
Protea	*Protea sp.*
Bitter Dock	*Rumex obtusifolius*
False Solomon's Seal	*Smilacina racemosa*

In the Denver Art Museum's exhibition entitled *Spirit of the Plains,* an Indian tipi and warrior artifacts used by the Indians of the North American Plains were displayed. These Plains Indians were big game hunters, the buffalo being the primary source of food and materials for clothing, shelter, and food. Showy clothing decorated with porcupine quill embroidery, fringe, and beadwork were typical of these Indians. The feathered warbonnet displayed was reserved for ceremonial purposes.

AUTHOR'S COMMENTARY: Six floral arrangements were designed to accompany the Indian scene. The basket containing the flowers displayed here was selected for its soft color tones similar to those seen in the painted art on the tipi, its sense of rhythm and open space suggesting the lifestyle of the Indian, and the effective use of natural materials such as Canada wild rye, anise, Northern sea oats, and Alpine currant.

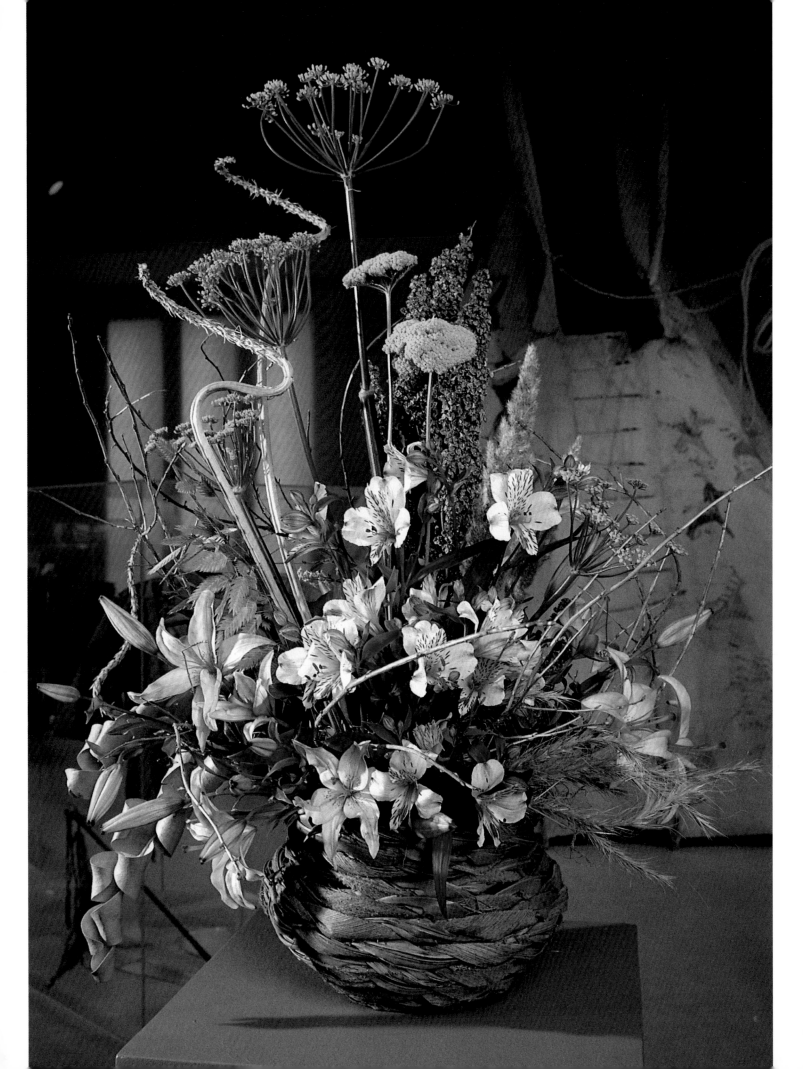

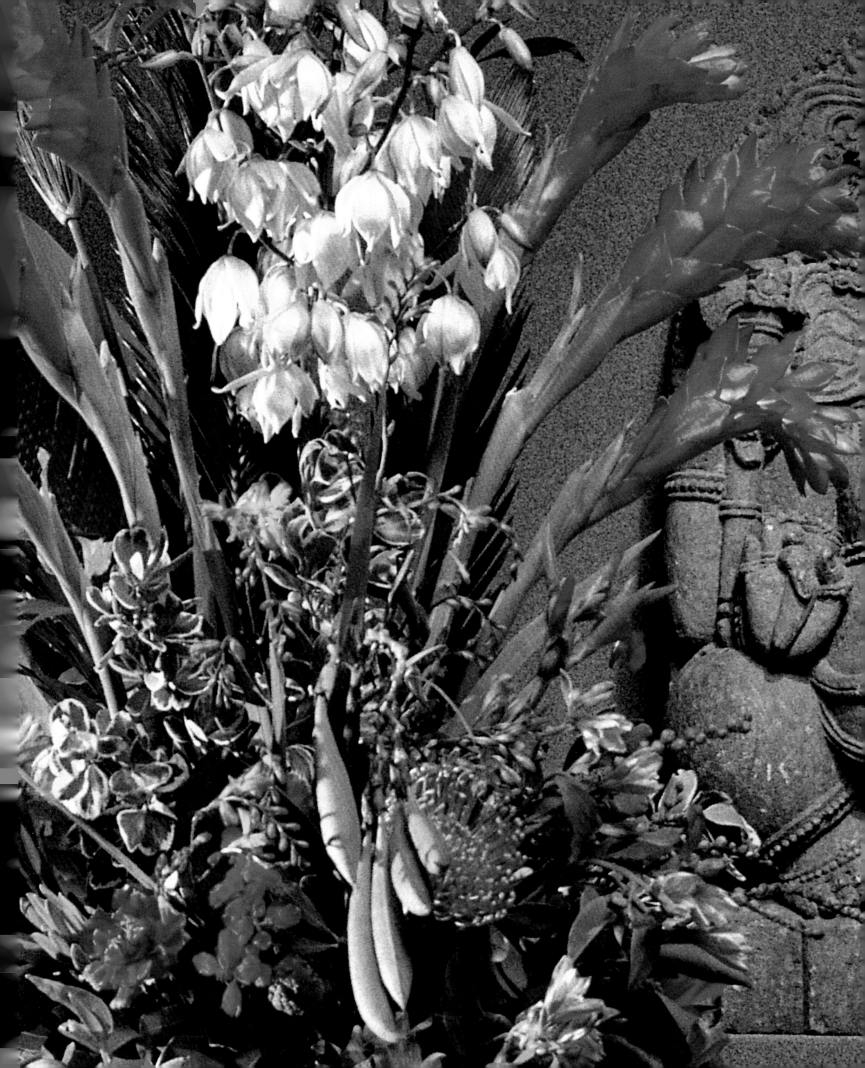

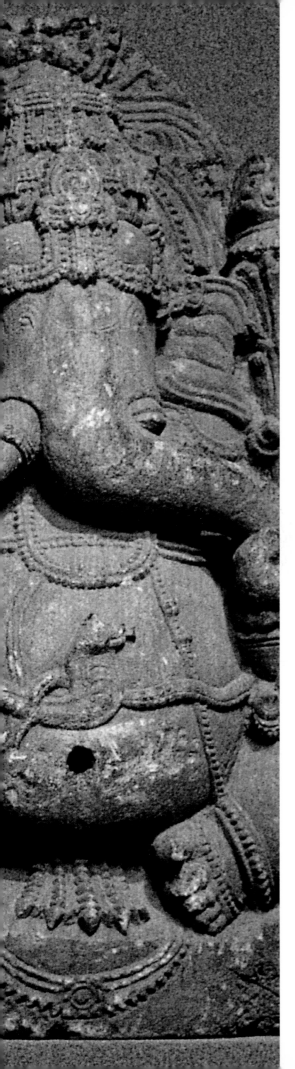

CHAPTER FOUR
Art of India

ENTRANCE TO ANCIENT INDIA

ASIAN ART MUSEUM OF SAN FRANCISCO
Entrance to Ancient India: A Tribute to the Color,
the Mystery, and the Magic of India
Boddhisattva Maitreya
Kushan period, 2nd-3rd century
Gandhara B60S597
The Avery Brundage Collection

Floral Design:
John Michel
John Michel Design

Materials:

Monoa Midnight Heliconia	*Heliconia sp. 'Monoa Midnight'*
Queen Protea	*Protea*
Sumac	*Rhus sp.*
Chocolate Bihai Heliconia	*Heliconia bihai 'Chocolate'*
Grevillea	*Grevillea sp. cv.*
Staghorn Sumac	*Rhus typhina*
Pin Cushion Protea	*Protea*
Cymbidium Orchid	*Cymbidium sp. cv.*
Perennial Flax	*Linum perenne*
Bird-of-Paradise	*Strelitzia reginae*
Bottle Brush	*Callistemon sp.*
Kangaroo Paw	*Anigozanthos sp.*

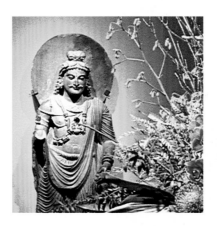

"I'll take you to worlds you never dreamed existed."
Mame Dennis

A bodhisattva is one who renounced Buddhahood in order to remain on earth and help mankind. Instead of the simple garment of a Buddha, bodhisattvas wear royal garments and jewelry. The Bodhisattva's left hand grasps a water bottle which identifies him as Maitreya, the next Buddha after Sakyamuni. His broken right hand would have displayed the gesture of reassurance.

Graeco-Roman influence is quite evident in the powerful modeling of this figure. The Bodhisattva wears strings of amulet boxes. Of particular interest is his pendant necklace of centaurs, creatures of Greek mythology.

Museum Wall Text

DESIGNER'S COMMENTARY: When I discovered that I was assigned the location at the entrance to the Ancient India Exhibit in the Asian Art Museum, it surprisingly reminded me of the ending of one of my favorite films: *Auntie Mame* starring Rosalind Russell. She is on her way to India and is taking her grand nephew with her. For "My tribute to the Color, Mystery and Magic of India", I chose flowers that had dark rich colors. These included the mauve and bronze cybidiums and the dark mahogany heliconia. Added to these were exotic tropical and native foliage. I attempted to bring the viewer into the arrangement and to discover shapes and textures that we are not used to seeing in more traditional arrangements.

Ancient India

GANESHA

VIRGINIA MUSEUM OF FINE ARTS
Ganesha
Indian (Karnataka, possibly from Halebid),
ca. early 12th century A.D.
Schist
Nashi and Alice Heeramaneck Collection
Virginia Museum, Gift of Paul Mellon 68.8.18

Floral Design:
Mrs. Thomas C. Slaughter III
Garden Club of the Northern Neck

Materials:

Ruscus	*Ruscus sp.*
Yucca	*Yucca sp.*
Torch Ginger	*Nicolaia elatior*
Heavenly Bamboo	*Nandina domestica*
Sago Palm	*Cycas revoluta*
Variegated Japanese Euonymus	*Euonymus japonica 'Variegata'*
Peruvian Lily	*Alstroemeria X aurantica*
Protea	*Protea sp.*
African Lily	*Agapanthus sp. cv.*
Canna	*Canna X generalis cv.*
Dwarf Papyrus	*Cyperus isocladus*
Dancing Lady Orchid	*Oncidium sp.*
Montbretia	*Crocosmia X cv.*

Few Hindu gods in India are more beloved than Ganesha. Wearing an intricately carved jeweled crown and seated in the position of royal ease, *Ganesha* is depicted here as a benign, regal divinity, ready to receive the worship of his many devotees. His trunk reaches toward a bowl of sweets that he holds in his lower left hand: in his upper left is a lotus. A serpent girds the god's ample belly, which is said to be full of his favorite sweet balls, symbolizing the seeds of the universe. The style in which *Ganesha* is carved is the Hoysala style, a type of "Indian rococo." The figure is almost obscured beneath a mass of ornamentation—anklets, bracelets, necklaces, and the tall crown. The fingers are covered with rings, as are the toes. Like much Indian sculpture, this piece, though three dimensional, is not carved in the round. Indian sculpture was generally placed within an architectural setting and thus could be viewed from only one vantage point.

Museum Wall Text

DESIGNER'S COMMENTARY: Ganesha is one of the most beloved of Hindu Gods in India, with a mystical story of creation. In this sculpture he is seated in a position of royal ease as though ready to receive worship or devotion which is depicted by the tall branch of nandina as a canopy or fan. His royalty is represented predominantly by a yucca bloom and red ginger as jewels in his crown.

Ganesha's round, full belly is represented by the circular arrangement in the center, including a protea, roses, and foliage. The vine wrapped around the vase portrays the snake he used as a belt.

The flowers were arranged in a bronze container with lotus leaves around the top reflecting the lotus he holds in his upper left hand. The arrangement was designed to simulate the sculpture which is best viewed from the front. The brilliance of the flowers reflects the mass of ornamentation and jewelry *Ganesha* wears.

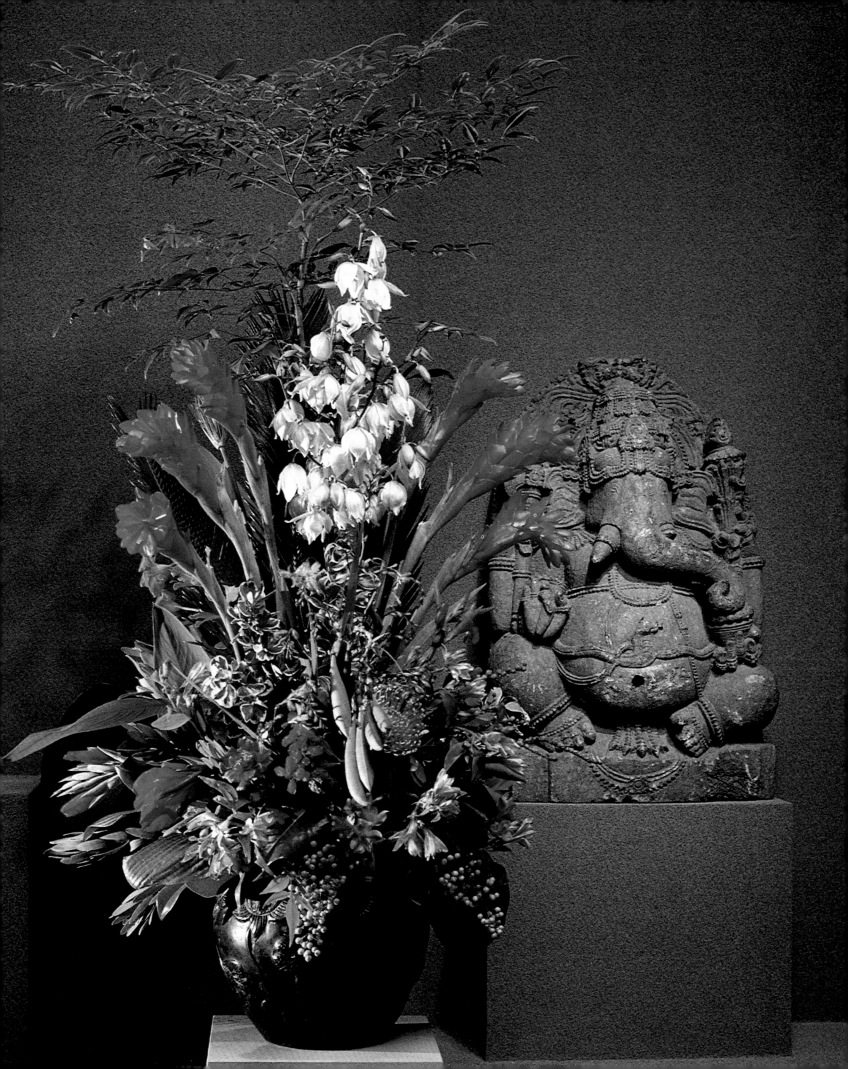

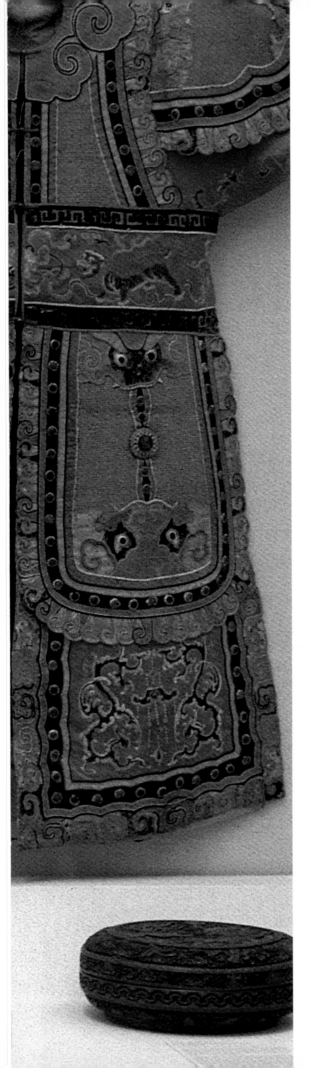

CHAPTER FIVE
Art of China

THEATRICAL ROBE

VIRGINIA MUSEUM OF FINE ARTS
Theatrical Robe
Chinese, Qing Dynasty, 18th century
Embroidered satin and velvet, silk, brocade
Glass in gilded metal mounts
Gift of Alan Priest
63.70

Floral Design:
Mrs. Richard Welton IV, Mrs. Thomas V. Rueger
Virginia Beach Garden Club

Materials:

Lily	*Lilium X cv.*
Heavenly Bamboo	*Nandina domestica*

In China, where the imperial court was always splendidly attired, the theater went to extraordinary lengths when it needed to create the enchanting illusion of fantasy-like spectacle. As a result, Chinese theatrical costumes often had exaggerated contours, brilliant colors, and bold designs. This striking robe, elaborately fabricated and sewn with glass jewels, was a costume for a warrior. Its panels of heavy, looped gold thread represent chain armor, and the border, made of bits of varicolored brocade, suggest the tiger with claws.

Museum Wall Text

AUTHOR'S COMMENTARY: The designers' choice of plant material; orange lilies, green foliage, and the brown wooden bucket with gold, reflect the earthy tones of the *Theatrical Robe*. The tall spread of nandina branches with cascading berries repeat the length and outstretched arms of the warrior's costume.

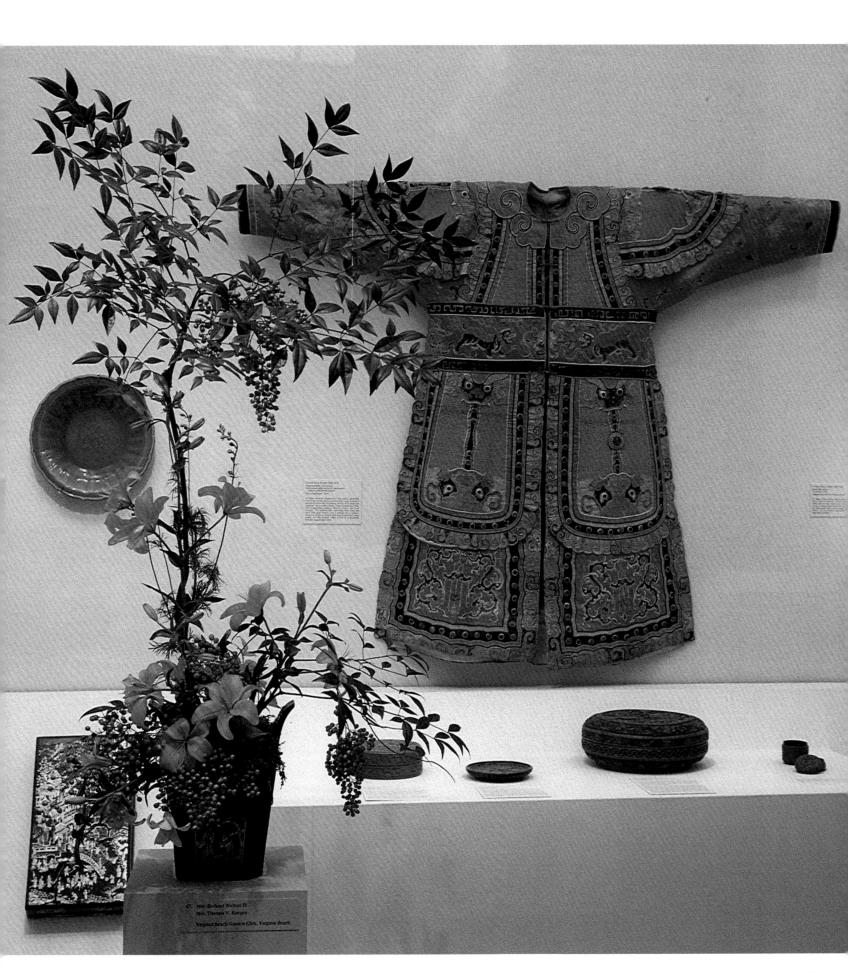

TREASURE WALL

ASIAN ART MUSEUM OF SAN FRANCISCO
Treasure Wall, Gruhn Court

Floral Design:
Mrs. William Seifert, Jr.
Orinda Garden Club

Materials:

Tulip	*Tulipa sp. cv.*
Ti	*Cordyline terminalis*
Lycopodium	*Lycopodium taxifolium*
Foxtail	*Retrofractis meyerii*
Tea Tree	*Leptospermum sp.*
Apple	*Malus sp. cv.*

The *Treasure Wall in the Gruhn Court* space of the Asian Art Museum introduces the collections to the visitor. It was the backdrop for an arrangement done for the preview of the Monet exhibit, March 1995.

DESIGNER'S COMMENTARY: My interpretation of the *Bouquets To Art* was an Asian interpretation of Monet's *Water Lilies* using white tulips and red dogwood branches to color coordinate with the painting.

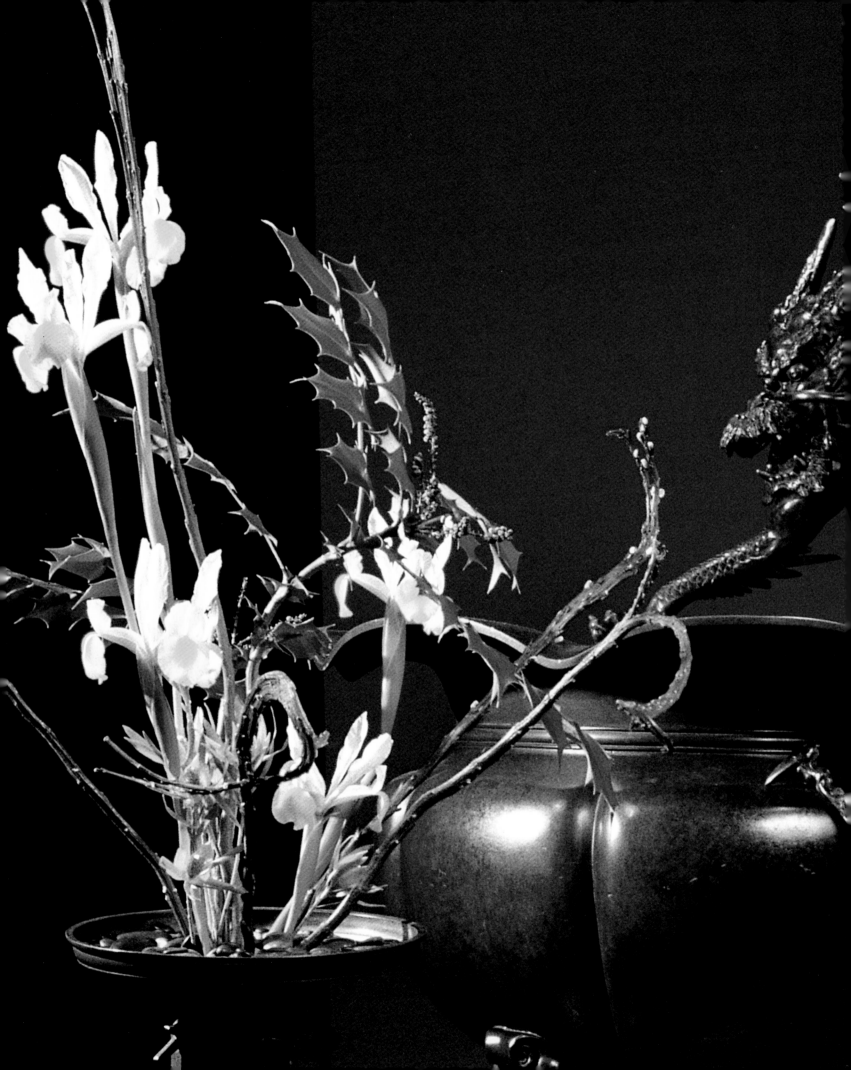

CHAPTER SIX
Art of Japan

TIGERS IN A BAMBOO GROVE

VIRGINIA MUSEUM OF FINE ARTS
Pair of Sliding Doors, Tigers in a Bamboo Grove
Japanese, ca. 17th century
Pigments on paper
Museum Purchase
The Williams Fund 66.71.1/2

Floral Design:
Mrs. Sondra J. Green
Midlothian Garden Club

Materials:

Bamboo	*Bambusaceae*
Heavenly Bamboo	*Nandina domestica*
Chrysanthemum	*Chrysanthemum X morifolium cv.*

Scenes of *Tigers in a Bamboo Grove* decorate this pair of sliding doors or walls (fusma), which originally divided rooms in Japanese monasteries and secular buildings. Tigers, which have great significance in Chinese native symbolism, first appeared in Japanese Zen Buddhist imagery as emblems of the forces of both nature and the human spirit that were to be mastered by spiritual insight. Frequently painted on the walls of Buddhist monasteries, they probably served as a challenge to the monks and as symbols of the mysteries of existence that must be penetrated to attain spiritual wisdom. Eventually the tiger motif spread from Zen Buddhist circles into the secular world. It appealed greatly to the Japanese military classes, for whom the tiger motif symbolized strength and virility. Kano school paintings of tigers, such as these, are very common. They were probably workshop productions based upon copy- book models of older versions.

<div align="right">Museum Wall Text</div>

AUTHOR'S COMMENTARY: In a dramatic floral interpretation of the Japanese screen, the designer has created a panel with its own grove of bamboo trees, using the chrysanthemum, the imperial flower of Japan, and yellow fugi mums rising out of the bamboo. Enhancing the gold background of the screen are yellow and gold mums which add brightness to the composition. The positioning of the bamboo makes it seem actually a part of the artist's bamboo grove. The nandina leaves that break through the clean black edge of the arrangement seem to belong to the painting, rather than to the floral design.

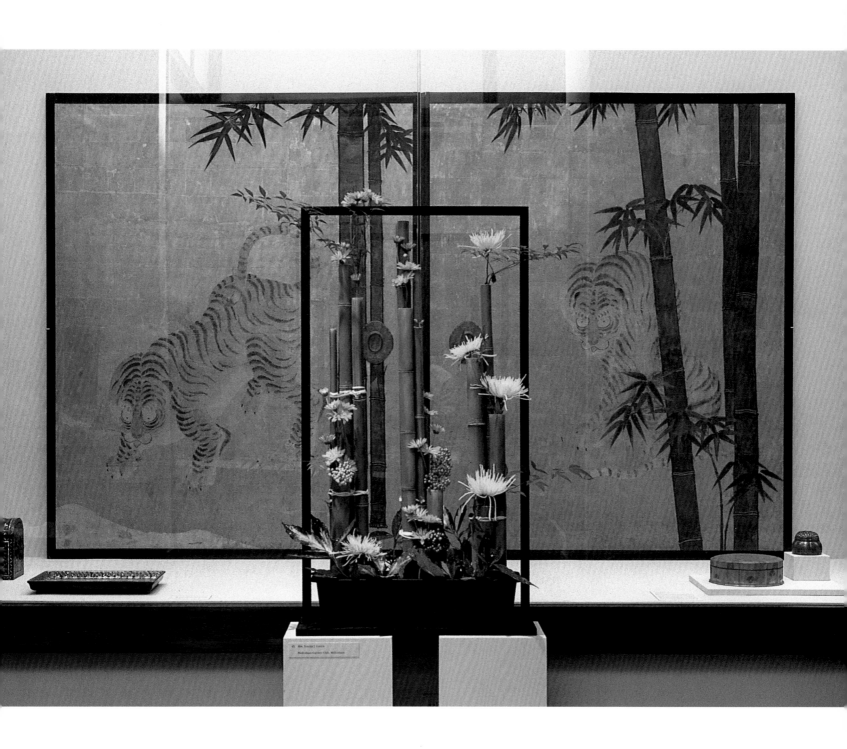

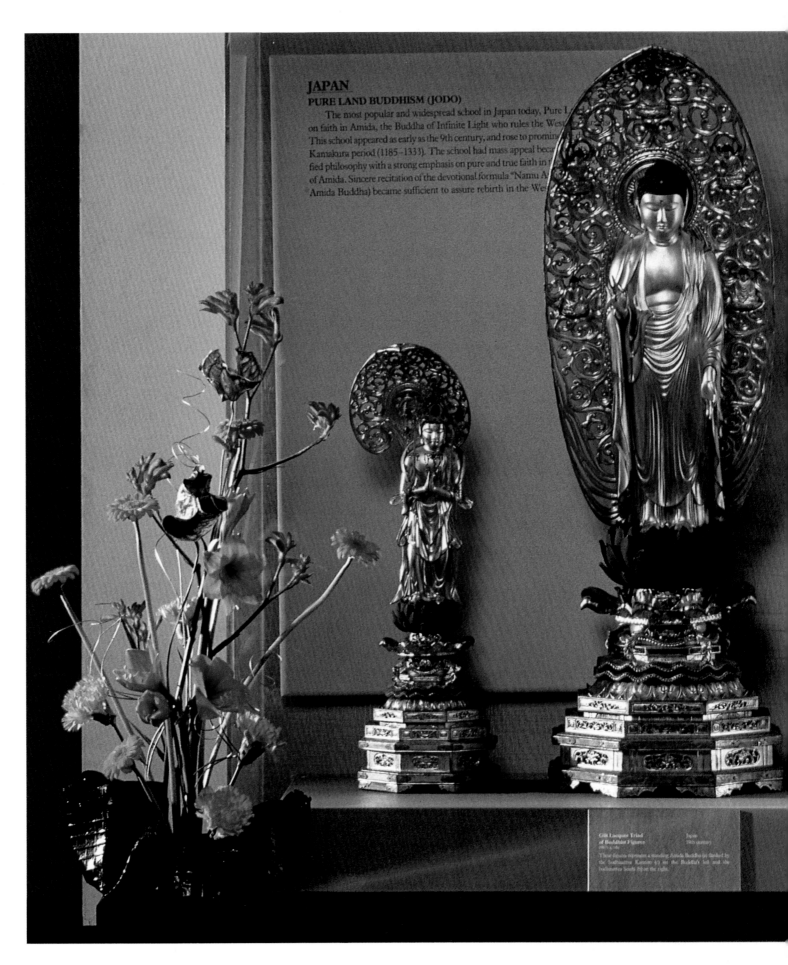

JAPAN
PURE LAND BUDDHISM (JODO)

The most popular and widespread school in Japan today, Pure L[...]
on faith in Amida, the Buddha of Infinite Light who rules the Wes[...]
This school appeared as early as the 9th century, and rose to promin[...]
Kamakura period (1185–1333). The school had mass appeal bec[...]
fied philosophy with a strong emphasis on pure and true faith in [...]
of Amida. Sincere recitation of the devotional formula "Namu A[...]
Amida Buddha) became sufficient to assure rebirth in the We[...]

Gilt Lacquer Triad
of Buddhist Figures
19th c.

Japan
19th century

These figures represent a standing Amida Buddha (r) flanked by
the bodhisattva Kannon (c) on the Buddha's left and the
bodhisattva Seishi (b) on the right.

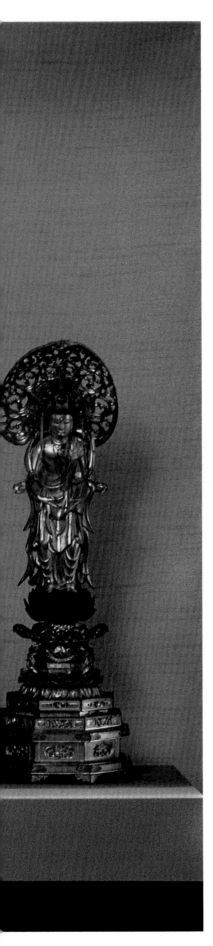

TRIAD OF BUDDHIST FIGURES

UNIVERSITY OF PENNSYLVANIA MUSEUM
OF ARCHAEOLOGY AND ANTHROPOLOGY
Triad of Buddhist Figures
19th century Japanese
Triad of Buddhist Figures: Amida, the Buddha
of infinite light who rules the western paradise,
is flanked by the Bodhisattvas, Kannon and
Seisha
Gilt Lacquer

Floral Design:
Jennifer Morrison, Gaby Haab,
Mary Jo Strawbridge
Garden Workers

Materials:
Carnation	*Dianthus caryophyllus cv.*
Transvaal Daisy	*Gerbera jamesonii cv.*
Kangaroo Paw	*Anigozanthus sp.*
Gladiolus	*Gladiolus X hortulanus*

Pure Land Buddhism (JODO) is the most popular widespread school in Japan today. Pure Land focuses on faith in Amida, the Buddha of Infinite Light who rules the Western Paradise. The school had mass appeal because of its simplified philosophy with a strong emphasis on pure and true faith in the saving powers of Amida. Sincere recitation of the devotional formula "Namu Amida Batsu"(Hail Amida Buddha) became sufficient to assure rebirth in the Western Paradise.

Museum Wall Text

AUTHOR'S COMMENTARY: The intent of the floral designers was to portray the state of illumination, which was imparted by the Buddha Amida to those who followed Pure Land Buddhism. The use of carefully spaced floral material interspersed with gilded pods give a strong sense of bright light reaching upwards. The flowers rise out of a folded black fabric container representing the lotus blossom at the feet of the Buddhist figures.

100 ASPECTS OF THE MOON

SANTA BARBARA MUSEUM OF ART
Selections from 100 Aspects of the Moon
Japanese Woodblock Prints
Yoshitoshi
Japanese, 1839-92
Gift of Carol L. Valentine

Left Print: ***Moon Through Smoke***
 Feb., 1886
 1987.53.22

Right Print: ***Moon On the Open Moor***
 May 20, 1888
 1987.53.63

Floral Design:
Kathleen Lemler
Director, Sangetsu School of Flower Arranging

Materials:

Kangaroo Paw	*Anigozanthus sp.*
Lily	*Lilium sp.*
Heavenly Bamboo	*Nandina domestica*
Love-in-a-Mist	*Nigella damascena*
Sudan Grass	*Sorghum sudanense*

Yoshitoshi was a printmaker who lived in Tokyo. He was the author of many series of prints depicting bijn, aspects of the moon, such as seen in this *Art In Bloom* exhibit.

Yoshitoshi was very popular and one of the last of true ukiyo-e artists working in the mainstream of the late ukiyo-e tradition. His best work was from 1873 until his death in 1892 . Tremendously popular, he was an artist of considerable imagination. The left print, *Moon Through Smoke*, depicts two firemen of the First Fire Brigade, standing on a rooftop holding their company's signal banner steady during a conflagration. The right print, *Moon On the Open Moor*, shows the Courtier Fujiwara no Yasumasa (958-1036) who charms the bandit Hakamadare Yasuke by playing his flute.

DESIGNER'S COMMENTARY: In creating the two arrangements to accompany the Japanese wood block prints, the designer explained that her principal intent was to create a work of art (floral) that was in harmony with another work of art (prints). Neither the art nor the flowers should overshadow one another.

The Sangetsu School of flower arranging effects changes in people and environments through the beauty of flowers. One flower arrangement is considered to be a small prototype of the universe. As flowers are arranged, a harmony is created between the designer and the universe, bringing peacefulness and healing to life.

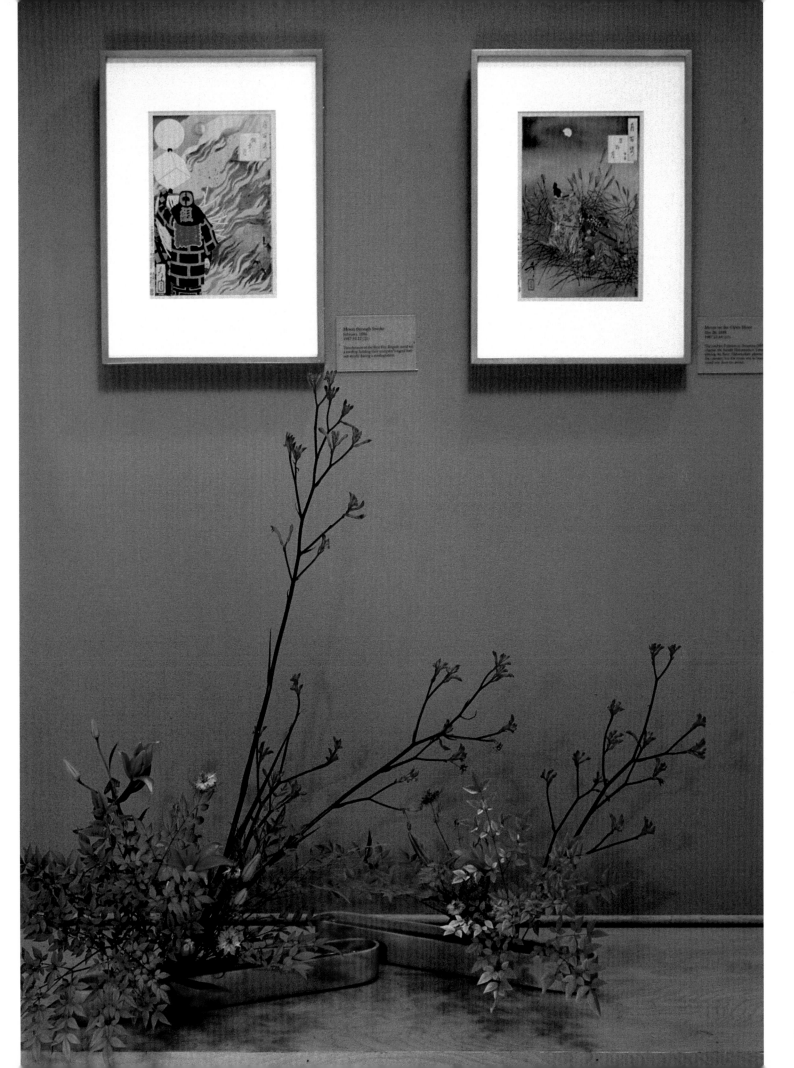

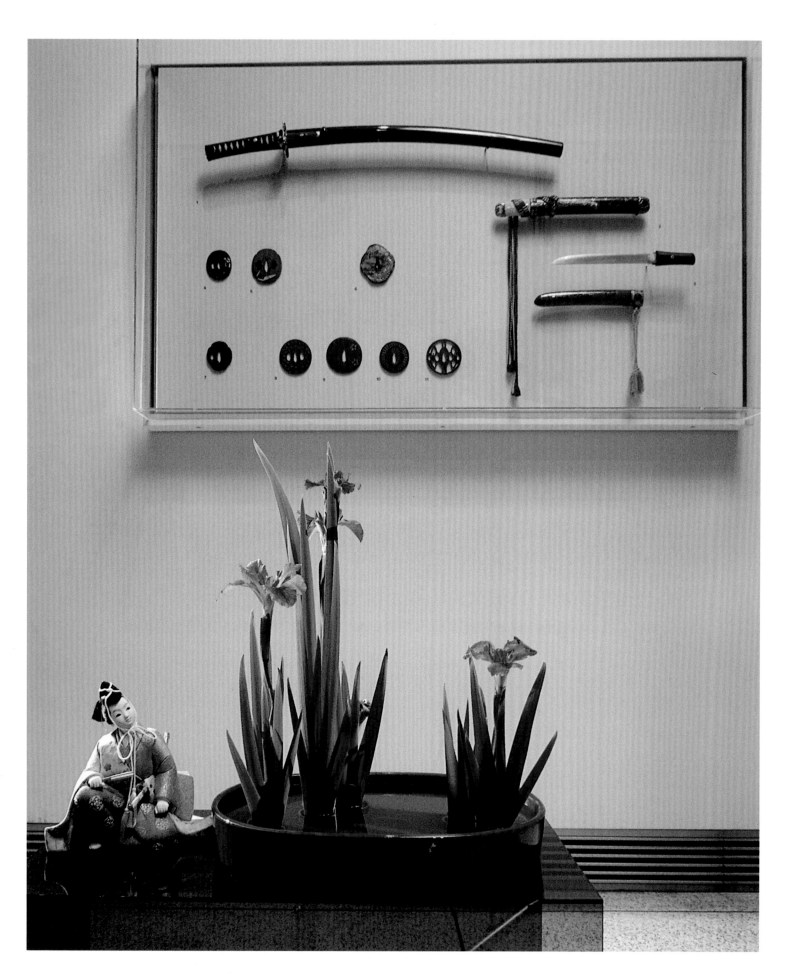

SWORDS

SAN DIEGO MUSEUM OF ART
Swords

Floral Design:
Teruko Hanson
Ikebana International Ohara School

Materials:
Iris *Iris sp.*

In early Japanese history, the sword was a functional fighting weapon with little adornment. As the feudal system developed, the ruling Samurai warrior class became powerful and rich. They soon favored swords that were not only utilitarian, but beautiful as well, to emphasize their owners' lofty station. As a result, decorative hilt designs, elaborate sword mounts, and lavishly decorated scabbards came into use.

The tsuba is a protective guard placed on the sword near the hand to prevent the opponent's sword from sliding forward during combat.

Museum Wall Text

AUTHOR'S COMMENTARY: The Japanese sense of understatement and restraint is displayed both in the arrangement of swords and tsuba, and the ikebana where iris rise from a pool of water. The scene encompasses a doll gazing at the beauty of nature. The elaborately decorated swords are presented as a work of art, well matched by the refined beauty of the floral design.

CHAPTER SEVEN
European Art
THIRTEENTH TO SEVENTEENTH CENTURY

TWO STAINED GLASS MEDALLIONS

MEMORIAL ART GALLERY OF THE
UNIVERSITY OF ROCHESTER
Two Stained Glass Medallions
Top: *Feast Scenes*
Bottom: *Two Servants*
French, Clermont-Ferrand, ca. 1255-1265
Potmetal and glass
Gift of James Sibley Watson
29.68, 29.69

Floral Design:
Annlouise Gent
Oatka Garden Club

Materials:

Delphinium	*Delphinium X elatum cv.*
Torch Ginger	*Nicolaia elatior*
Carnation	*Dianthus sp.*
Plume Poppy	*Macleya cordata*
Prairie Gentian	*Eustoma grandiflorum*
Golden Yarrow	*Achillea X filipendulina 'Coronation Gold'*

DESIGNER'S INTERVIEW: The two red ginger florals

represent the two running figures in the lower window

while the cream lisianthus depicts the purity of Christ

in the upper window. The container was made by the

designer's son, Eric Gent.

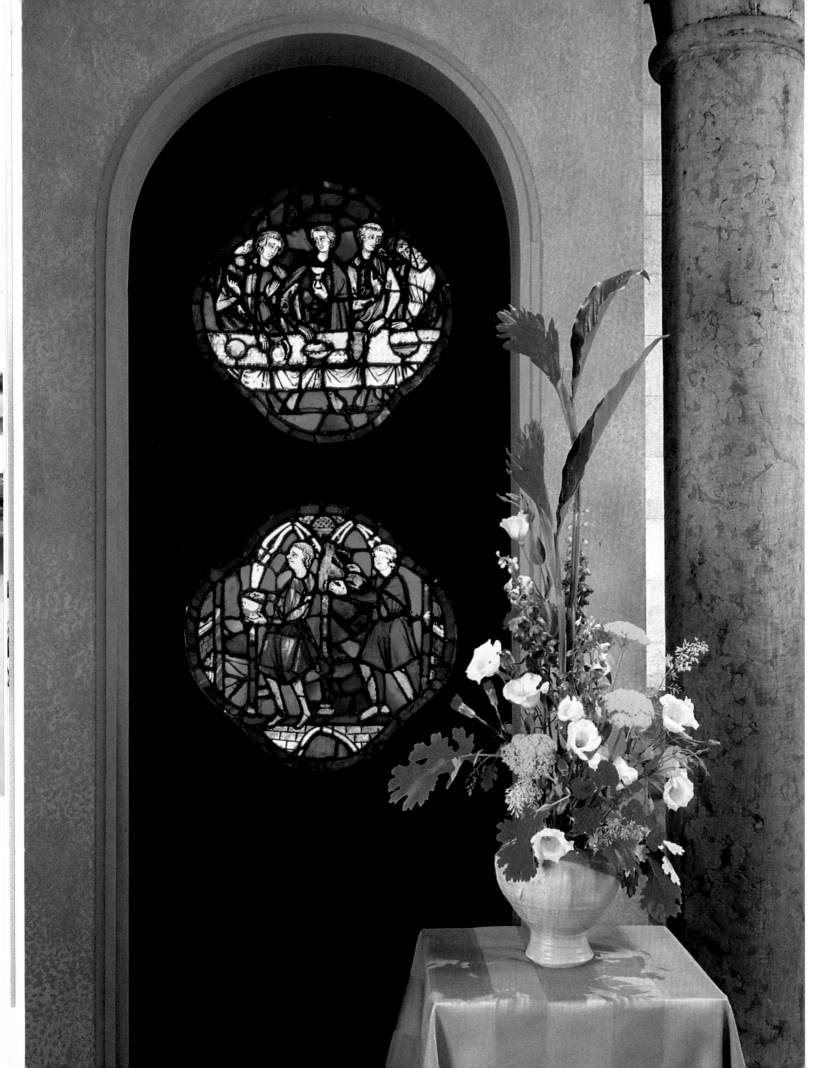

PORTRAIT OF A GENTLEMAN

MUSEUM OF FINE ARTS, HOUSTON,
Portrait of a Gentleman, possibly 1512
Bartolommeo Veneto
Italian, Venetian School, active 1502-1530
Oil on panel
The Edith A. and Percy S. Straus Collection
44.573

Floral Design:
Sarah Bergner
Sara Bergner Design

Materials:

Peony	*Paeonia lactiflora cv.*
New Zealand Tea Tree	*Leptospermum scoparium cv.*
California Pepper Tree	*Schinus molle*
Kangaroo Paw	*Anigozanthos sp.*
Anemone	*Anemone coronaria*
Sweet Pea	*Lathyrus odoratus*
Lily	*Lilium X cv.*

Bartolommeo's portrait of an unknown man is a typical and superb example of his mature portrait style with its characteristic Venetian use of opulent color and rich adornments blended with a north Italian or even Germanic simplicity. "Standing against a red curtain, the sitter averts his gaze, his firmly set jaw contrasting with the slightly wistful expression in his eyes. The young man's costume bespeaks his aristocratic rank: his cloak is trimmed with rich fur, the border of his tunic is shot through with threads of gold, and he wears an elaborate cap badge of gold and enamel."

*A Permanent Legacy, 150 Works From the Collection
of the Museum of Fine Arts, Houston*

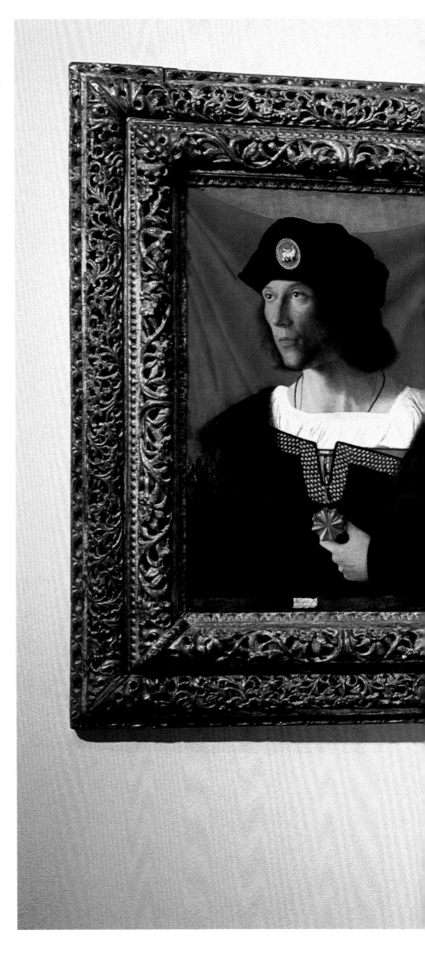

DAVID AND BATHSHEBA

WALTERS ART GALLERY
David and Bathsheba, Italian, ca. 1552
Paris Bordone, Italian (Venetian), 1500-71
Oil on canvas
37.2371

Floral Design:
Polly Pinder, Ruth Murphy
Caroline County Garden Club, FGC

Materials:

Scotch Broom	*Cytisus scoparius*
Blazing Star	*Liatris sp.*
Statice	*Limonium sinuatum*
Fan-tail Willow	*Salix sachalinensis 'Sekka'*

Bordone specialized in creating complex architectural compositions, and here the dramatic interaction of the perspective lines serve to bind the figures together. From his palace window at the upper left, King David gazes down at Bathsheba who is bathing. As related in II Samuel 11:2, the king desired her and they had an adulterous relationship.

Museum Wall Text

AUTHOR'S COMMENTARY: The upward sweeping movement of the liatris, scotch broom, and fasicated willow give the feeling of the height of the columns and architecture in the painting. The left arm of Bathsheba also rises in a curving line similar to the scotch broom. There are three figures in the painting; King David, a servant, and Bathsheba, represented in the placement of the protea. The lowest protea (Bathsheba) is the most open and beautiful. The soft green vase and variety of leaves and foliage at the base of the arrangement add balance and repeat the rich analogous tones of the art.

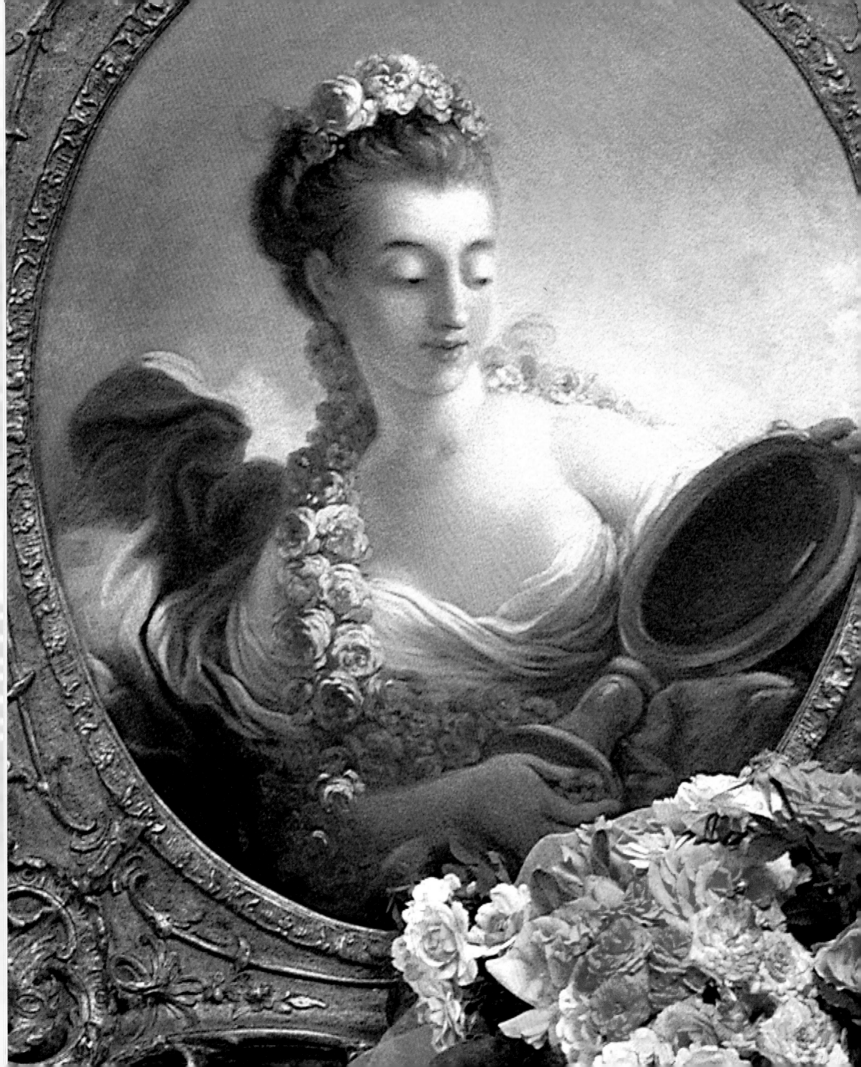

CHAPTER EIGHT
European Art
EIGHTEENTH AND NINETEENTH CENTURY

BACCHANAL

MUSEUM OF FINE ARTS, HOUSTON
Bacchanal, ca.1747
Charles-Joseph Natoire, French, 1700-1777
Oil on canvas
Museum purchase
84.200

Floral Design:
Mark Ruisinger
Galloway Florist, Inc.
Flowers provided by
Mr. and Mrs. Isaac Arnold, Jr.

Materials:

Rose	*Rosa X cv.*
African Lily	*Agapanthus X cv.*
Queen Anne's Lace	*Daucus carota var. carota*
Peony	*Paeonia lactiflora cv.*
Grape	*Vitis sp.*

Charles-Joseph Natoire, highly acclaimed in mid-eighteenth-century France, was particularly famous as a decorative painter. *Bacchanal,* commissioned by Ange-Laurent de La Live de Jully, one of the most distinguished collectors of the mid-eighteenth century; it celebrated de La Live's wedding in 1747. The god of wine, Bacchus, is seen surrounded by fawns and nymphs, who taste with him the pleasure of vintage. This painting is an excellent example of Natoire's rococo style, characterized by an elegant draftsmanship, richly worked oil paint, and luxurious sense of color. Its sensuous, elaborately decorative design and transparent pigments are expressive of French taste in art in the mid-eighteenth century.

AUTHOR'S COMMENTARY: This unusually large, dramatic floral arrangement contains all the elements found in the *Bacchanal* painting. The movement of figures, both earthly and angelic, the gnarled and fanciful trees, the swirling garland and draperies are repeated in the upward reaching arrangement. The foliage flying out of the twisting grapevine and surrounding the grapes evokes the central tree in the painting where the cavorting figures are gathered. The luxurious colors used by Natoire are expressed in the principal flowers; peach flesh-toned roses, vibrant red peonies and roses, and purple agapanthus. A large cluster of grapes cascades from the grouping of roses, repeating the theme of wine and merriment.

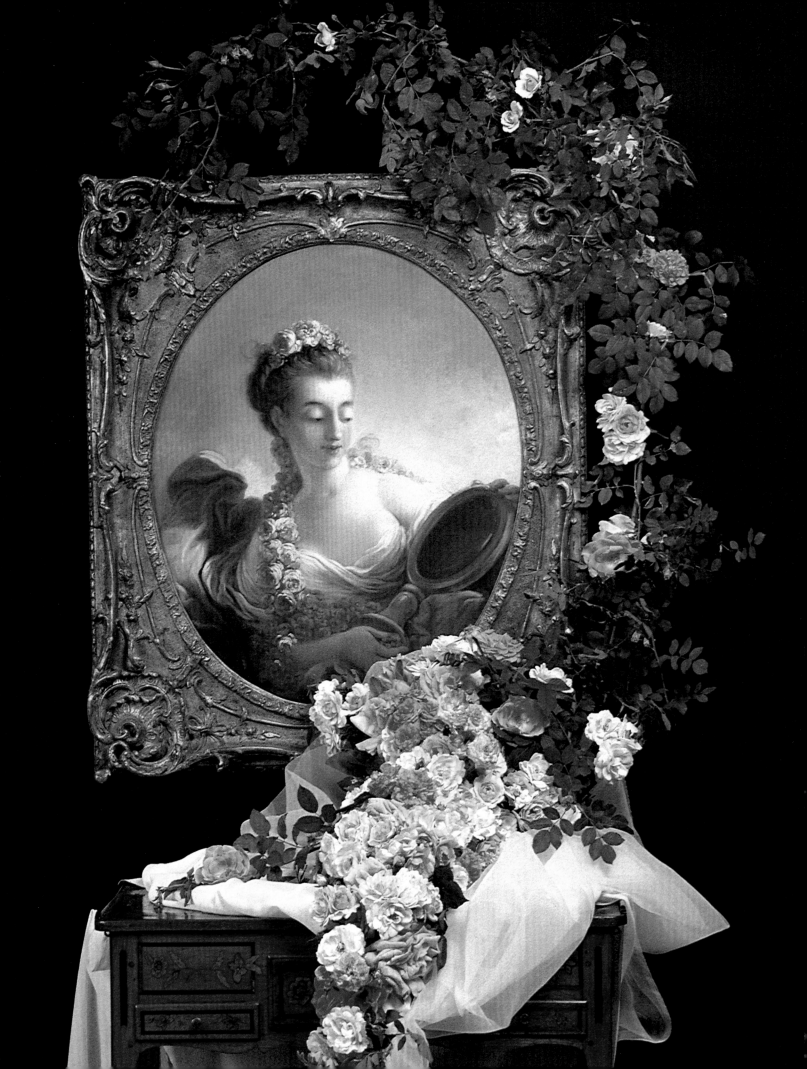

MADEMOISELLE MARIE-MADELEINE GUIMARD

UNIVERSITY OF UTAH MUSEUM OF FINE ARTS
Mademoiselle Marie-Madeleine Guimard, 1772
Jean-Honoré Fragonard, French, 1732-1806
Oil on canvas.
Gift of Val A. Browning

Floral Design:
Holly Clark Wright

Materials:

Elsa Poulson Rose	*Rosa X 'Elsa Poulson'*
Cecil Bruner Rose	*Rosa X 'Cecil Bruner'*
Cherish Rose	*Rosa X 'Cherish'*
Tropicana Rose	*Rosa X 'Tropicana'*
Bonica Rose	*Rosa X Meideland 'Bonica'*

Mademoiselle Marie-Madeleine Guimard, the celebrated French dancer and for twenty-five years the star of the opera, was the rage of eighteenth-century Paris. Her beauty and charm has been immortalized in her portraits by Fragonard and by all the critics of the time for her ability and sheer delight as a dancer. In addition to creating her portrait, Fragonard created a series of masterpieces for the decoration of her splendid residence in the Rue de la Chausée d'Antin, known as the temple of Terpsichore, where this portrait hung.

Museum Text

DESIGNER'S COMMENTARY: Marie-Madeleine Guimard, the French opera star and dancer, was a truly exquisite woman. You can imagine how she loved to be admired. She evidently was also one of her own fans, as we see her celebrating her beauty in the mirror. Perhaps that is why she chose to adorn herself with the flower of lasting beauty, the rose. I chose to continue her painted cascade of pink roses with garden roses in my design interpretation. The soft texture and colors portray the essence of her feminine charms.

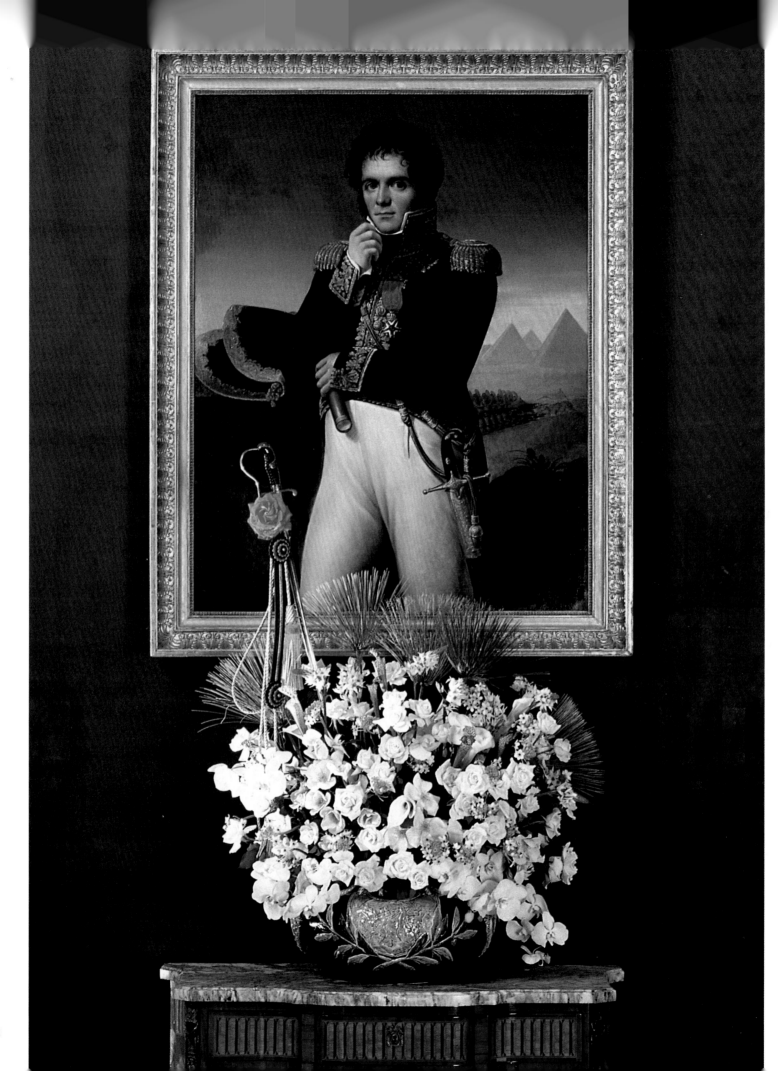

PORTRAIT OF JEAN LOUIS REYNIER

UNIVERSITY OF UTAH MUSEUM OF FINE ARTS
Portrait of Jean Louis Reynier, ca. 1805-06
José Aparicio Y Inglada, Spanish, 1793-1838
Oil on canvas
Gift of the Marriner S. Eccles Foundation for the
Marriner S. Eccles Masterworks Collection 84-60

Floral Design:
Regina Garner
Gina's Extravagant Flowers

Materials:

Bridal White Tea Rose	*Rosa X odorata 'Bridal White'*
Rugosa Rose	*Rosa rugosa*
Moth Orchid	*Phalaenopsis sp.*
Star-of-Bethlehem	*Ornithogalum arabicum*
Wonder Flower	*Ornnithogalum thyrsoides*
Calla Lily	*Zantedeschia aethiopica*
Cobra Lily	*Arisaema sp. or Sarracenia sp.*

José Asparicio Y Inglada was a student of and workshop assistant to Jacques Louis David. As his name indicates, he was originally from Spain. Throughout the Napoleonic years, Inglada was one of the leading portrait painters in the Neoclassical style. This *Portrait of Jean Louis Reynier*, Marshall of France, also reminds us of the authoritarian aspects of the Napoleonic era and the excitement which attended the conquests Napoleon was making for France. The atmosphere of the era depicted in the swaggering military style of Reynier displays the wishes of the military leaders of the time for the immortality which such a portrait could confer.

Museum Text

DESIGNER'S COMMENTARY: The painting had such a strong presence which I interpret as feelings conjured up from my East Prussian heritage along with my travels to Egypt. Gallantry, honor, nobility, and even romanticism are thoughts I attach to this painting. These notions could only be represented by the pure and beautiful tints and variations of white. The juxtaposition of strong vertical lines of the papyrus against the soft and round shapes of the roses and the phalaenopsis orchids speak of the controversy Napoleon's Egyptian campaign left in the history of time. The single red rose attached to the sword not only mirrors the color of the beribboned chest, but speaks of romantic feelings we attach to the life of a soldier, especially one who has served in an exotic, far-away place such as Egypt. The rose also represents the blood spilled in battle and the short-lived vitality of a soldier's cause.

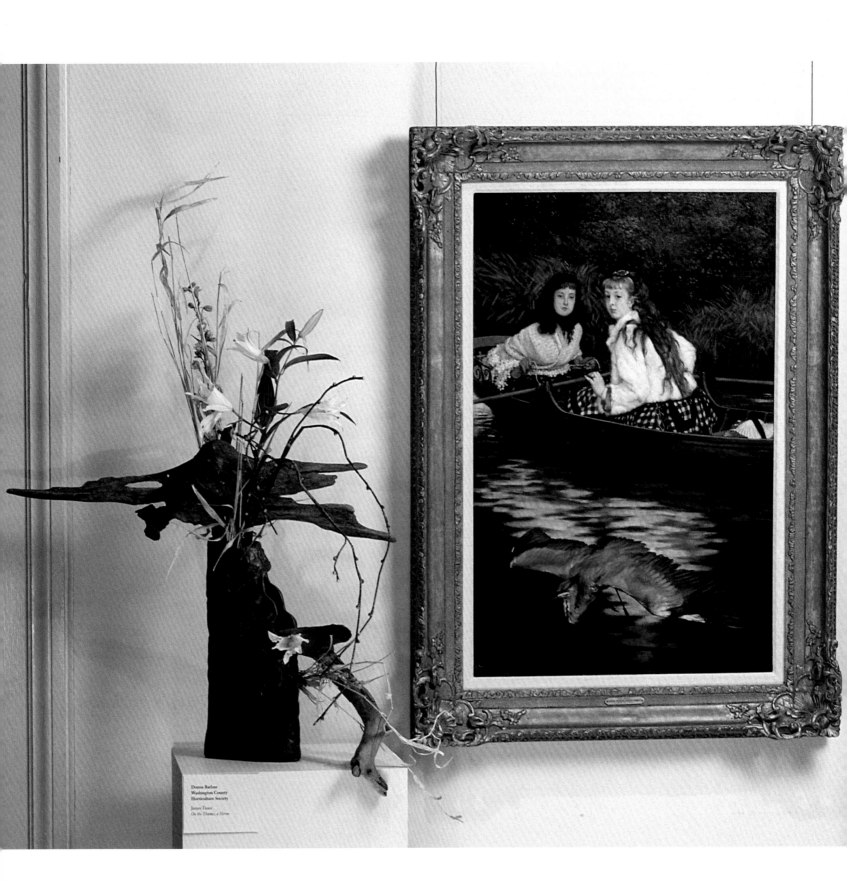

Donna Barlow
Washington County
Horticulture Society

James Tissot
On the Thames, a Heron

ON THE THAMES, A HERON

MINNEAPOLIS INSTITUTE OF ARTS
On the Thames, a Heron, after 1871
James Jacques Joseph Tissot, British , 1836-1902
Oil on canvas
Gift of Mrs. Patrick Butler by exchange
75.7

Floral Design:
Donna Barlass
Washington County Horticultural Society

Materials:

Corkscrew (or Curly) Willow	*Salix matsudana 'Tortuosa'*
Daylily	*Hemerocallis X cv.*
Grasses	
Driftwood	

James Jacques Joseph Tissot, an Anglo-French artist, was a resident of Paris until 1871 when he moved to London. Tissot showed a preference for high-gloss finish and a restriction to black and white or cool gray tones, as seen in this painting. His tightly painted surfaces were in contrast to the brushy style of the Impressionists, showing an Anglo-Saxon reserve and decorum, despite his French origins. Tissot was a vital force in the art world of London.

AUTHOR'S COMMENTARY: The designer has used the same somber color tones in her container, drift wood and plant materials as Tissot chose for his painting. The unusual placement of the wood pieces reflects both the boat and the bird in the foreground. Curly willow connects the wood and suggests the girl's long hair. White lilies accentuate the white blouses and faces of the two girls.

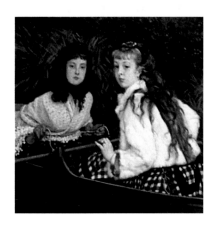

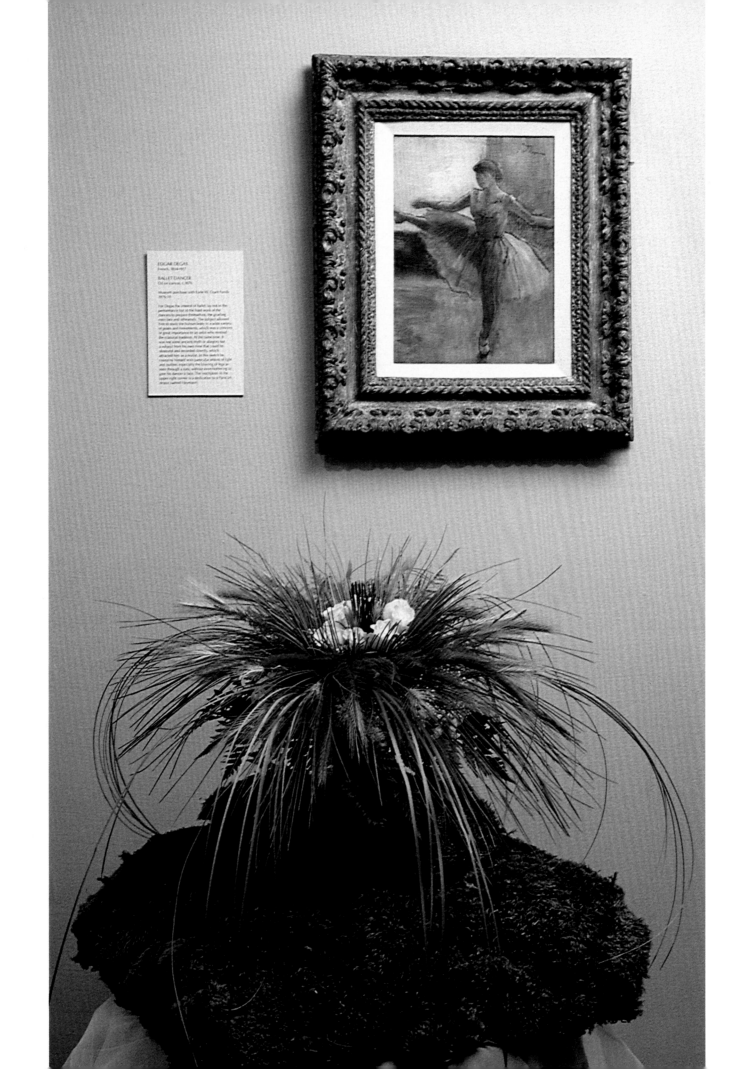

LA CORYPHÉE (THE BALLERINA)

SAN DIEGO MUSEUM OF ART
La Coryphée (*The Ballerina*), ca.1876
Edgar Degas, French, 1834-1917
Oil on canvas
Museum Purchase by the
Earl W. Grant Acquisition Fund
1976.111

Floral Design:
Kimberly Pavel

Materials:
Sphagnum Moss	*Sphagnum sp.*
Leather Fern	*Rumohra adiantiformis*
Statice	*Limonium sinuatum*
Wheat	*Triticum aestivum*
Bear Grass	*Xerophyllum tenax*
Rose	*Rosa X cv.*

For Degas, the interest of ballet lay in the hard work of the dancers to prepare themselves through grueling exercises and rehearsals. This subject allowed him to study the human body in a wide variety of poses and movements, which was a concern of great importance to an artist who revered the classical tradition. In this sketch he concerns himself with the particular effects of light and outline, especially the blurring of legs as seen through a tutu, without even bothering to give his dancer a face.

Museum Wall Text

AUTHOR'S COMMENTARY: This interpretation of Degas' dancer is a fascinating and unusual arrangement. On a two-tiered moss base, the dancer's tutu of bear grass and wheat flies out from a bodice of petite white roses surrounding a small clump of wheat. The grasses burst outward and curl down from the delicate contained center like the tutu of a dancer in motion. The soft beige of the wheat picks up the color tones in the background of the painting. This fresh interpretation of a dancer enhances Degas' small sketch.

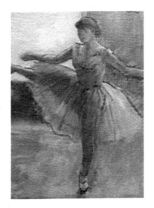

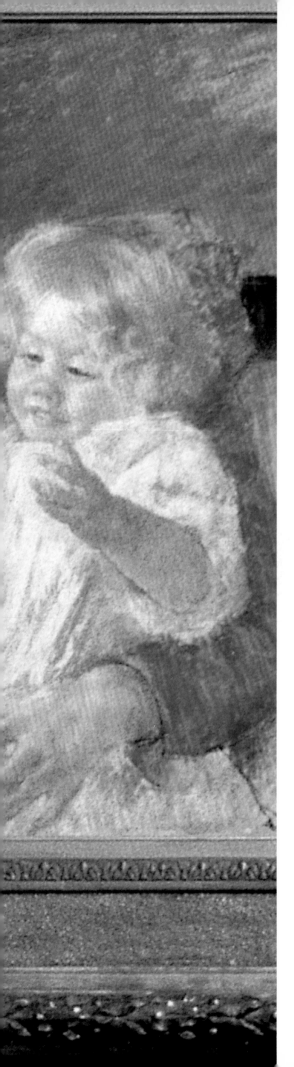

CHAPTER NINE
American Art

NINETEETH AND TWENTIETH CENTURY

GOODWIN TAVERN SIGN

1995 Fine Art and Flowers
WADSWORTH ATHENEUM
Hartford, Connecticut
Goodwin Tavern Sign
Hartford Connecticut, after 1810
William Rice, American, 1773-1847
Oil on panel
Gift of Mrs. Walter L. Goodwin
1952.296

Floral Design:
Joan Gallucci, Mary Lou Gore
Comina, Inc.

Materials:

Transvaal Daisy	*Gerbera jamesonii cv.*
Lily	*Lilium X cv.*
Cineraria	*Senecio X hybridus*
Ivy	*Hedera sp.*

William Rice, born in Worchester, Massachusetts, settled in Hartford, where he advertised himself as a "Sign-Painter." Rice painted this trade sign for the Goodwin tavern, which was built in Hartford in 1810. He depicted the lion with startling human features, especially in its warm, golden eyes. The lion often served as a symbol of British monarchy, and Rice's choice of a chained lion may refer to the end of British rule in America. Taverns at this time frequently attracted traveling animal shows; a lion from one of these shows may have inspired Rice's image. The tavern sign served as one of the earliest forms of American advertising, and Rice is considered one of our first commercial artists.

Museum Wall Text

AUTHOR'S COMMENTARY: The table-scape, called *Lunch At the Lion Inne* was designed to accompany the *Goodwin Tavern Sign*. The simple table setting with wooden chairs and a single candlestick is reminiscent of early nineteenth-century conveniences. The orange gerberas and lilies, arranged in a tankard, complement the tawny orange fur of the chained lion with doleful eyes. On the pedestal to the left sits a golden carafe of brandy with glasses. The few sprigs of ivy tie this small setting to the larger arrangement of flowers on the table. A tarnished old lantern sits on the floor beside the chair, reminding us of Early American dining before the advent of electric lighting.

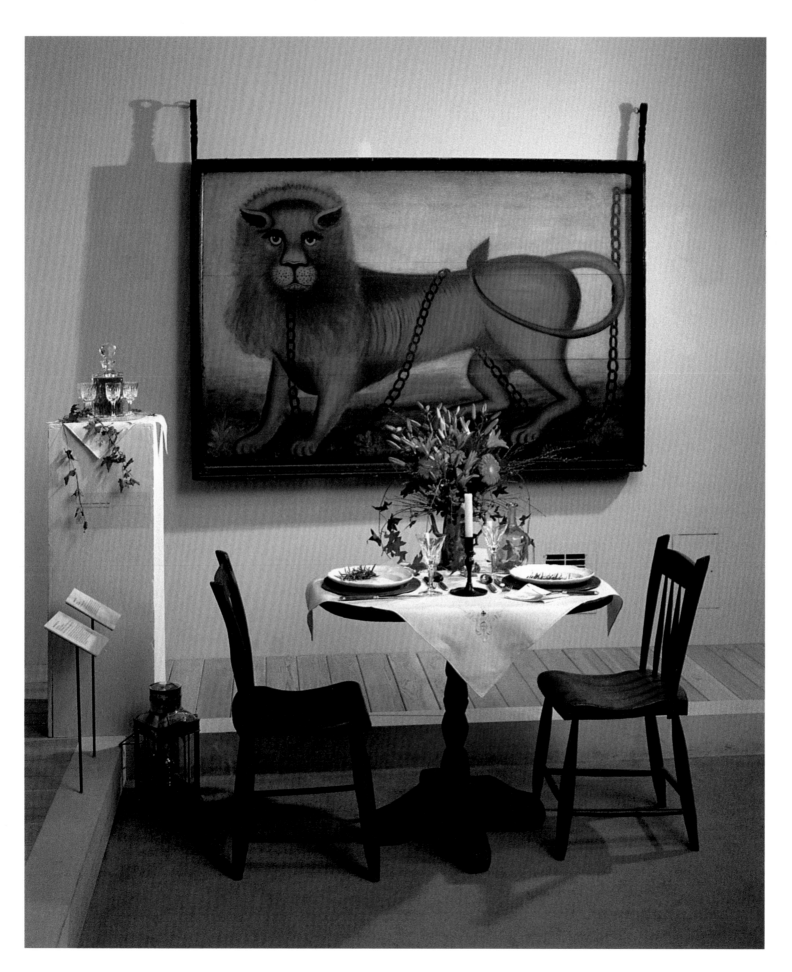

KAATERSKILL FALLS

1995 Fine Art and Flowers
WADSWORTH ATHENEUM
Hartford, Connecticut
Kaaterskill Falls, 1826
Thomas Cole
American, 1801-1848
Oil on canvas
Bequest of Daniel Wadsworth
1848.15

Floral Design:
Sandy Taylor
Garden Club of New Haven
Nantucket Garden Club

Materials:

Ming Fern	*Polyscias fruticosa 'Elegans'*
Lily	*Lilium X cv.*
Queen-Anne's-Lace	*Daucus carota var. carota*
Rose	*Rosa X cv.*
Carnation	*Dianthus sp. cv.*
Peruvian Lily	*Alstroemeria X aurantiaca*
Larkspur	*Consolida ambigua*
Barberry	*Berberis sp.*
Delphinium	*Delphinium X elatum cv.*
Fan-tail Willow	*Salix sachalinensis 'Sekka'*

Thomas Cole, whose mature career spanned the second quarter of the nineteenth century, is called the founder of The Hudson River School of American landscape painting. His compositions of real or imaginary scenery, produced between 1825 until his untimely death in 1848, established landscape painting as a viable alternative to portraiture for professional artists in the United States. In *Kaaterskill Falls*, Cole captured the dramatic scenery through his depiction of the pounding of the falls and the ominous storm clouds overhead. Cole chose an unusual vantage point for his composition, from beneath the arch of the cavern under the falls, thrusting the viewer directly into the scene. By 1887 Kaaterskill Falls was considered one of the scenic wonders of the northeast.

AUTHOR'S COMMENTARY: In this effective interpretation of *Kaaterskill Falls*, the use of textures, colors, and scale is evident. From the white delphinium, tiny blossoms of Queen Anne's lace cascade below the container representing the splash of the white falls on the painter's canvas. Soft peach lilies and roses on the upper right put life and light into both the arrangement and the painter's sky. The rust tones in the lower landscape carry across to the arrangement with the rust-colored carnations and roses. Branching fasciated willow reaches outward and up, giving the viewer both a sense of ominous movement and the dark brown tones used in the painting. The large scale of the arrangement defines the expanse of scenery painted by Thomas Cole.

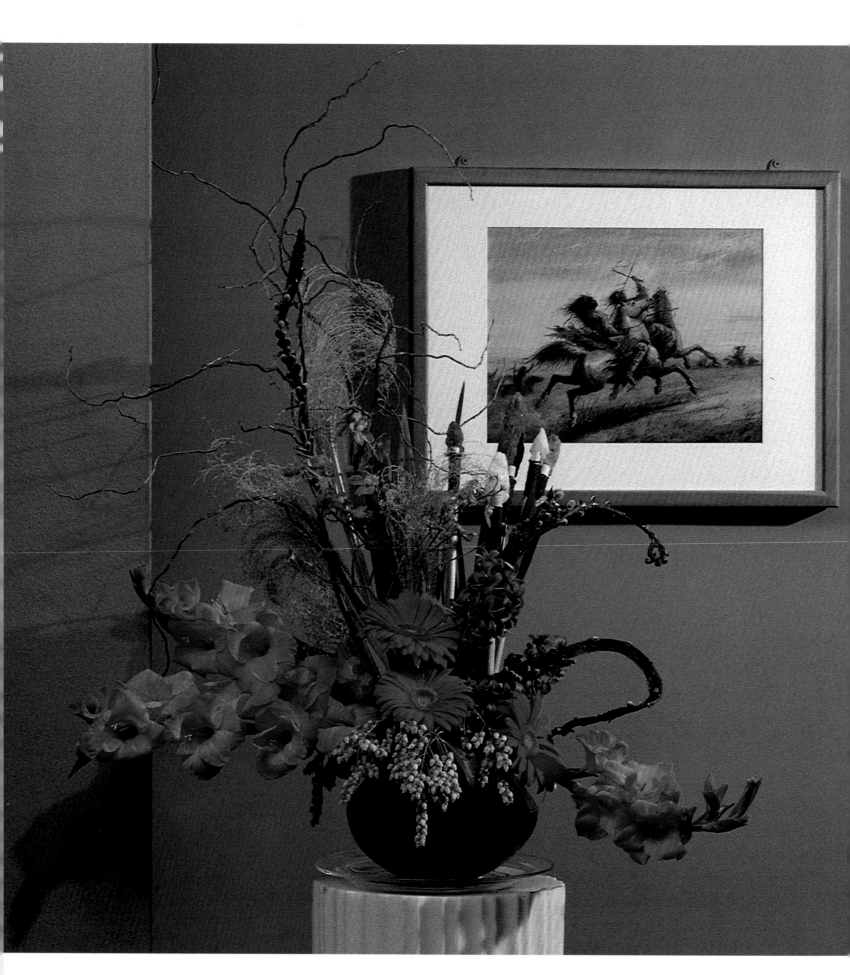

THE WAR PARTY

WALTERS ART GALLERY
The War Party, 1858-60
Based on sketches of ca. 1838
Alfred Jacob Miller
American, Baltimore, 1810-1874
Watercolor on paper
37.1940.148

Floral Design:
Barbara Warfield, Ann Rogers, Mary Scrivener
Howard County Garden Club, FGC

Materials:

Contorted Willow	*Salix matsudana 'Tortuosa'*
Fan-tail Willow	*Salix sachalinensis 'Sekka'*
Grass	*Poaceae*
Delphinium	*Delphinium X elatum cv.*
Hyacinth	*Hyacinthus X cv.*
Gladiolus	*Gladiolus X hortulanus cv.*
Transvaal Daisy	*Gerbera jamesonii cv.*
Japanese Pieris	*Pieris japonica*
Arrowhead Vine	*Syngonium podophyllum*

Within a vast landscape, Miller includes a host of riders galloping over the prairies. Our attention wanders over the scene, stopping on the main figures, but moving on. In 1837, Miller accompanied a Captain Stewart on an expedition to Wyoming and Utah where he drew hundreds of sketches of tribal life. He used many of the sketches for oil paintings. Miller returned to Baltimore where he had been born and in 1858 commenced a commission from William Walters to produce 200 watercolors based on his early sketches.

Museum Wall Text

AUTHOR'S COMMENTARY: The arranger's use of orange-reds in the gladiolas and gerbera daisies repeats the strong horizontal movement of the Indians galloping on horseback. The upward thrust of the Indian shooting in the painting is carried out with the willows, grass plumes, and arrowheads. Delphiniums and hyacinths echo the artist's use of blues in the painting.

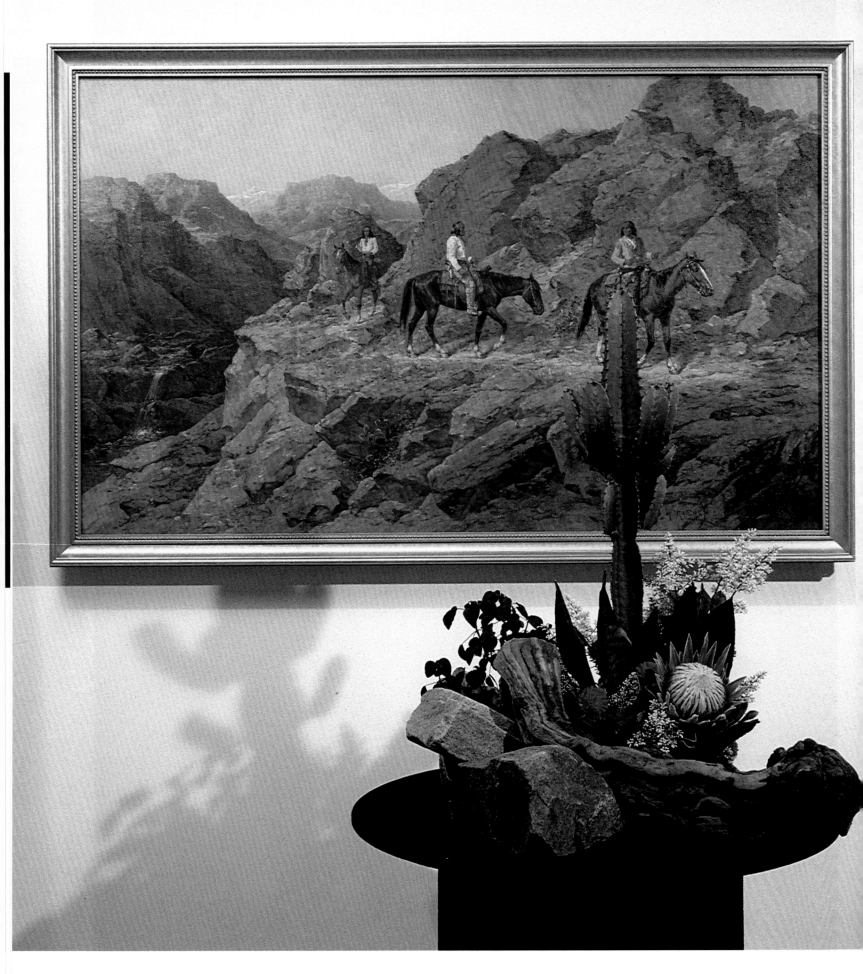

THREE AMERICAN INDIANS ON A ROCKY MOUNTAIN TRAIL

SAN DIEGO MUSEUM OF ART
Three American Indians
On a Rocky Mountain Trail, no date
Henry Raschen, American, born German,
1854-1937
Oil on canvas
Gift of Mr. and Mrs. Rea Axline
1993.54

Floral Design:
Rumi M. Rice
Ikebana International Sogetsu School

Materials:
Wood
Cactus *Cactaceae*
Wild Flowers

Born in Germany, Henry Raschen moved with his parents to Fort Ross, California in 1868. On completion of his studies in Europe from 1875-1883, he settled on the family ranch in Sonoma County where his models were the Native Americans of Mendicino County. Following a second European study trip in 1890, he established a studio in San Francisco. Raschen's paintings were more in demand in Europe than in America. His landscapes, such as the San Diego picture, indicate he worked in Colorado and Arizona among the Arapahos and Apaches.

Museum Text

AUTHOR'S COMMENTARY: The rock structures at the base of the arrangement echo the colors and shapes of the mountains where the Indians are riding. Carefully selected variety in both shapes and color of the floral material is effectively placed among the rocks of the arrangement. The upright cactus reflects the erect posture of the Indians and carries the compositional arrangement into the painting. Orange, red, and rusty brown floral material harmonize with the predominant color palette used by the artist.

PORTRAIT OF
MRS. GEORGE GORDON CRAWFORD

BIRMINGHAM MUSEUM OF ART
Portrait of Mrs. George Gordon Crawford, 1921
Howard Chandler Christy
American (1873-1952)
Oil on canvas
Gift of Mrs. Albert Gordon Rives

Floral Design:
Cathy Blach, **Marty Culver**
Jasmine Flowerwork

Materials:

Phlox	*Phlox sp.*
Lily	*Lilium sp.*
Waterfall Weeping	
Higan Cherry	*Prunus subhirtella 'Pendula'*
Verbena	*Verbena*
English Ivy	*Hedera helix*
Tulip	*Tulipa sp.*
Viburnum	*Viburnum sp.*
French Rose	*Rosa gallica*
Llac	*Syringa sp.*

Howard Chandler Christy was a turn-of-the-century American artist known for his portraits of world celebrities painted during the 1920s. His works reside in Washington D.C. in the Capitol, the White House, the State Department, and the Post Office Building. His classical *Portrait of Mrs. George Gordon Crawford* (1921) reflects the cosmopolitan, European-oriented tradition popular during this period. Elegance, refinement, and beauty are all expressed in this example of society portraiture. The creamy, delicate tones of the skin and the lace bodice are accentuated against the subtle background and dark clothing. The touch of red in the fan adds drama to the portrait.

AUTHOR'S COMMENTARY: In this beautiful floral design, one senses the same composed, controlled, classical elements observable in the painting. The cascade of weeping cherry reflects the elegant curving line of the subject's draped arm, as the vines do the drapery and the texture of her gown. The pale delicacy of the formal flowers and the weathered quality of the column play on the contrast between the translucence of her complexion and the richly modeled background.

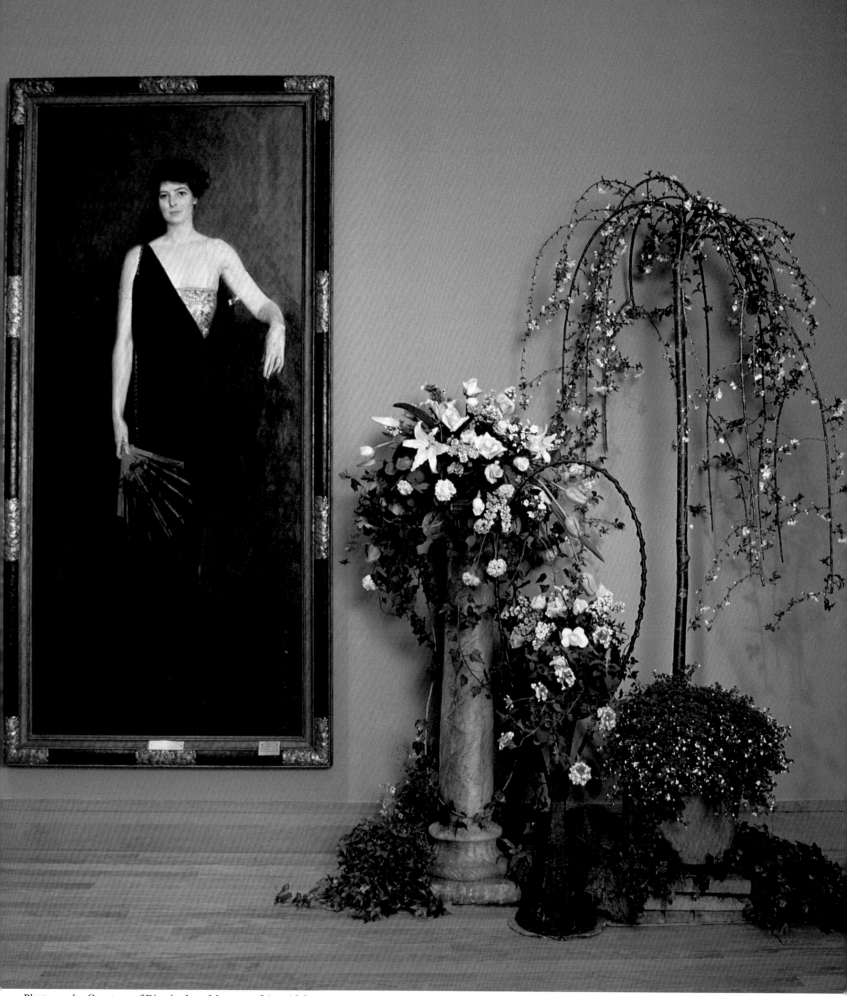

Photography Courtesy of Birmingham Museum of Art, Alabama

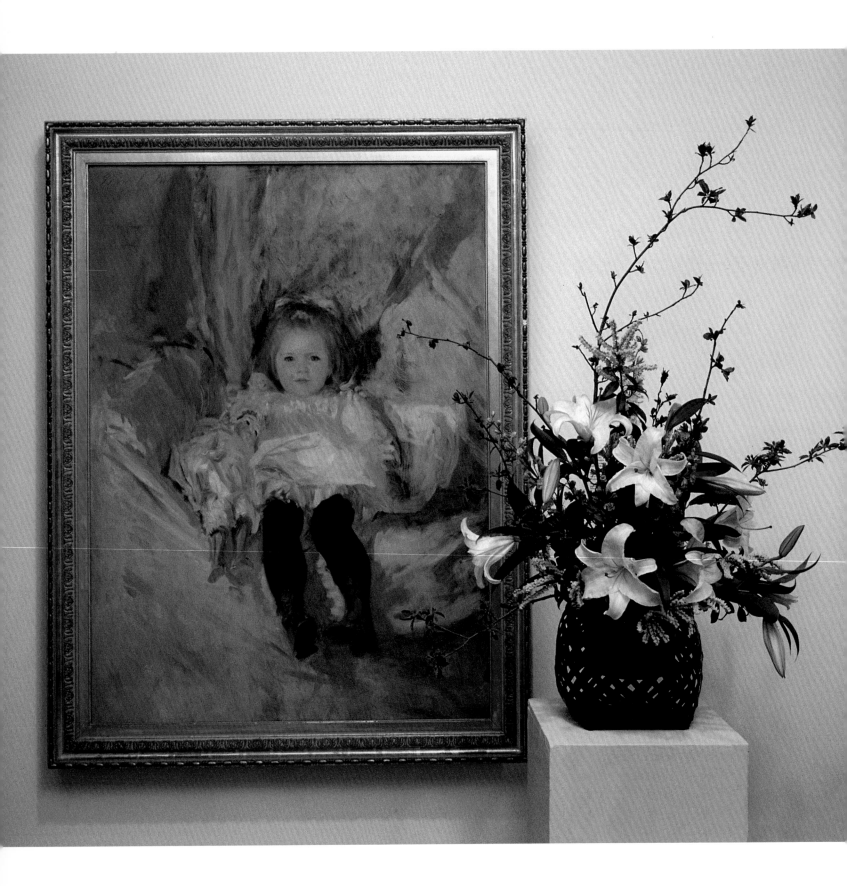

PORTRAIT OF RUTH SEARS BACON

1995 Fine Art and Flowers
WADSWORTH ATHENEUM
Hartford, Connecticut
Portrait of Ruth Sears Bacon
John Singer Sargent
American, 1856-1925
Oil on canvas
Gift of Mrs. Austin Cheney
1975.92

Floral Design:
Mary Kaufmann

Materials:

African Lily	*Agapanthus sp. cv.*
Casablanca Lily	*Lilium X 'Casablanca'*
Crabapple	*Malus sp. cv.*
Larkspur	*Consolida ambigua*

John Singer Sargent was an international artist whose urbanity suffused his art. Sargent was born in Italy of American parents, and trained there as well as in Paris. He was soon recognized as one of the foremost portraitists of his time and satisfied demands for portraits from the great and fashionable. Throughout his career he made many trips to America, the first in 1876. This portrait of Ruth Sears Bacon at age three (later Mrs. Austin Cheney) was painted in Newport, Rhode Island during Sargent's second trip to this country in 1887.

Museum Text

AUTHOR'S COMMENTARY: The freshness and charm of this young girl nestled in plump white bedding with her doll is captured in the pure white lilies, the lacy black basket reflecting her stockings, and pink larkspur echoing the soft rosy faces of the child and her doll. The curved branches of crabapple lift and lighten the design, suggesting the soft curving legs of Ruth.

STAINED GLASS WINDOWS

DETROIT INSTITUTE OF ARTS
Stained Glass Windows
John LaFarge, American, 1835-1910

Floral Design:
Marilyn Gushée
Art & Flowers Chairman, 1985
Garden Club of Michigan
Junior League Gardeners
Grosse Pointe Garden Club
Pat Wasson
Art & Flowers Chairman, 1993

Materials:

African Lily	*Agapanthus sp. cv.*
Bells-of-Ireland	*Molucella laevis*
Contorted Willow	*Salix matsudana 'Tortuosa'*
Delphinium	*Delphinium X elatum cv.*
Fern	*(various)*
Ivy	*Hedera sp. cv.*
Lily	*Lilium X cv.*
Dancing Lady Orchid	*Oncidium sp.*
Rose	*Rosa X cv.*
Salal	*Gaultheria shallon*
Statice	*Limonium sinuatum*
Ruscus	*Ruscus aculeatus*

John LaFarge (1835-1910), a leader in many different aspects of American art in the late nineteenth century, is often called the "Father of mural paintings in America." During his career, LaFarge produced several thousand stained glass windows, developing an opalesque luster in the glass such as that seen in the stained glass windows he executed for the First Unitarian Church in Detroit in 1890.

DESIGNER'S COMMENTARY: During the Victorian period, floral art reached fabulous new heights and large floral fantasies, designed to impress, were seen everywhere. Typical was a large compact mass bouquet with its outline broken by arching or spiraling elements such as ivy. Ferns were a Victorian passion. The rose was the most popular source of inspiration for pattern, and decoration appeared everywhere.

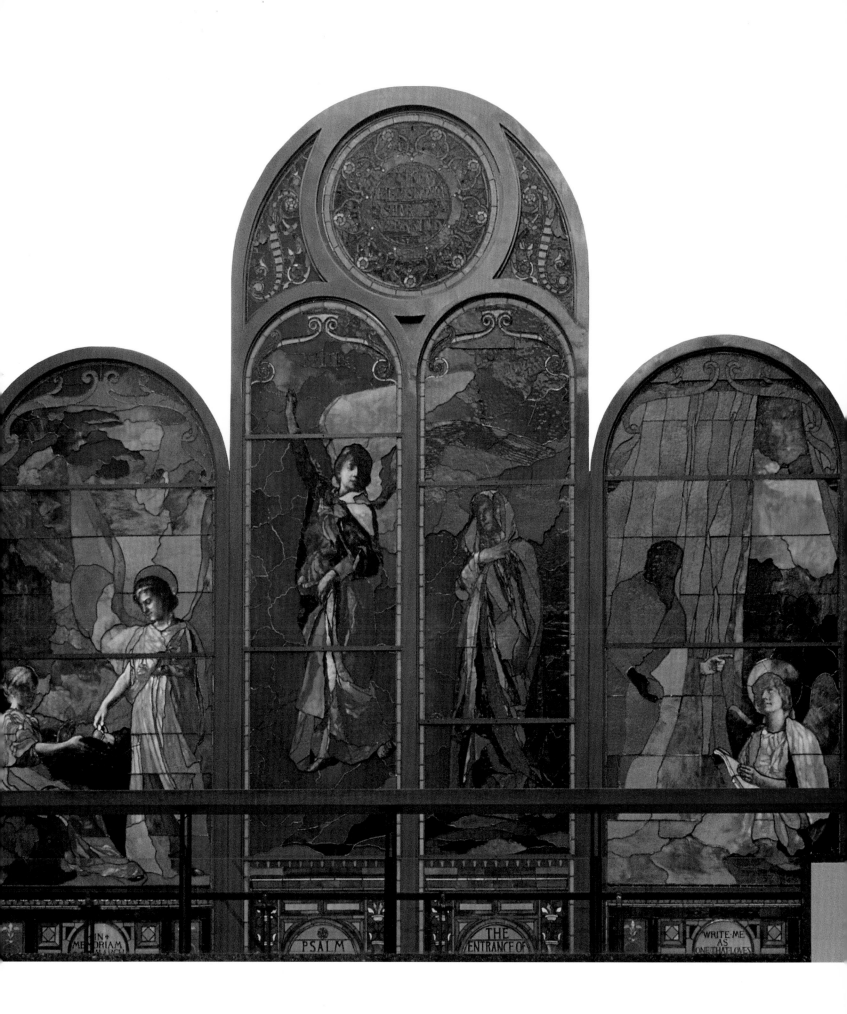

Twentieth Century Art

PAIR OF WINDOWS

VIRGINIA MUSEUM OF FINE ARTS
Pair of Windows (for the Avery Coonley
Playhouse, Riverside, Illinois), 1912.
Frank Lloyd Wright
American, 1867-1959
Gift of Sydney and Frances Lewis
85.348.1-2

Floral Design:
Mrs. H. McPherson Janney, Jr.
Rappahannock Valley Garden Club

Materials:
Dutch Iris *Iris x xphium cv.*
Pom Pom chrysanthemum *Chrysanthemum x mori*
 folium cv.
Red Carnation *Dianthus*
 caryophyllus cv.

Frank Lloyd Wright, America's first indisputably modern architect, developed his early brilliant style between 1900-1910. Wright's aim was not simply to design a house, but to create a complete environment. He took command of the details of the interior; designing stained glass, furniture, and even fabrics. Wright's stained glass, as seen in *Pair of Windows*, shows his mastery of simple patterns, with each piece of glass a geometric shape. Wright understood the balance between repetition of forms found in nature. Green and orange glass are colors of the prairie plants that Wright used in virtually all of his art-glass work. Very few of his stained-glass windows use blue glass. These windows for a playhouse used the primary colors of red, yellow, and blue and are unusual in Wright's work.

AUTHOR'S COMMENTARY: In the striking floral arrangement to accompany *Pair of Windows*, the designer has used lead sparklers both horizontally and vertically to simulate the lead used in the windows. The bright, clear colors of the purple iris, red chrysanthemums, and yellow mums in blue glass containers repeat the bright colors of glass in the windows. A mound of red chrysanthemums represents the red circular shaped glass while all other floral lines are straight as in the leading of the windows, whose shapes and patterns are effectively repeated in the black wrought-iron container.

Museum Wall Text

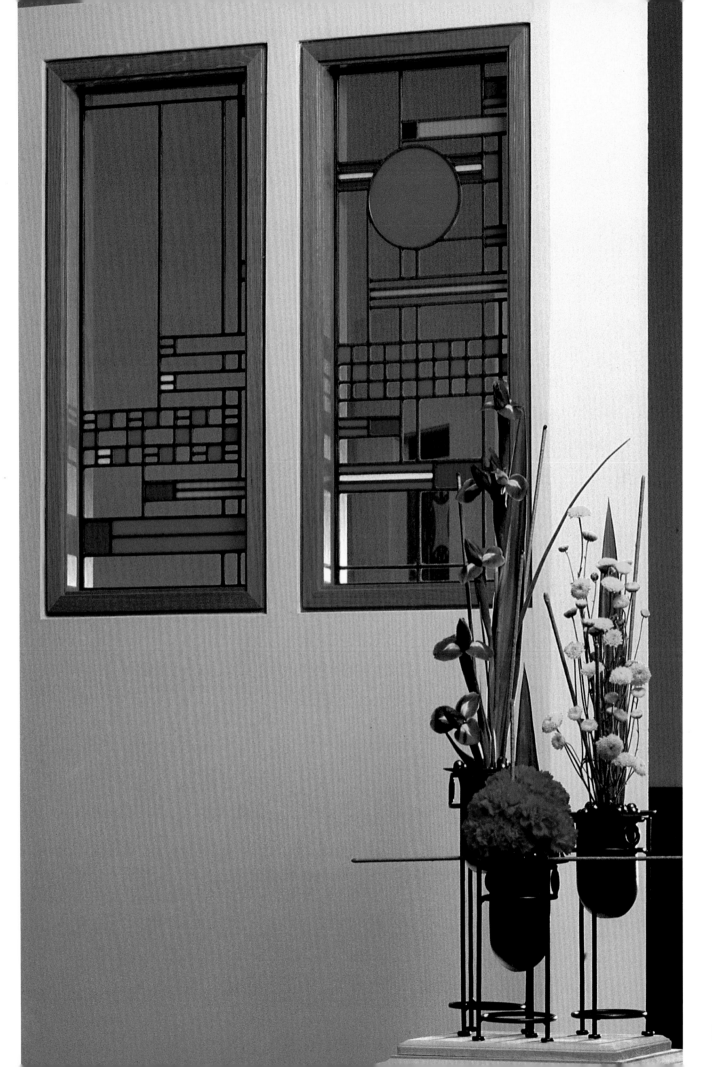

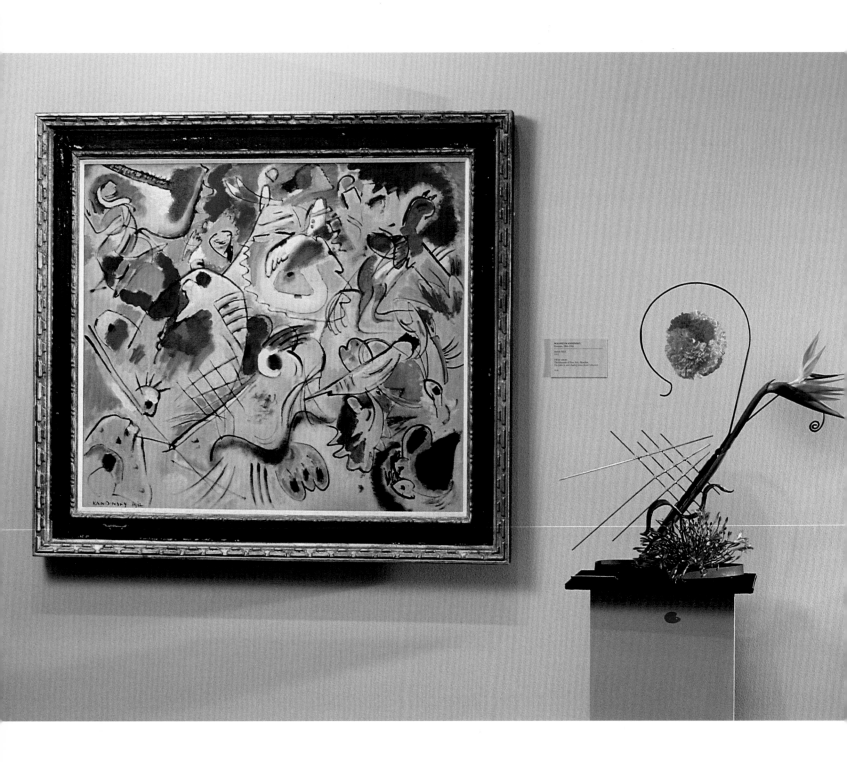

SKETCH 160 A

MUSEUM OF FINE ARTS, HOUSTON
Sketch 160 A, 1912
Wassily Kandinsky
Russian, Moscow; 1866 Neuilly-sur-Seine,
France 1944
Oil on canvas
The John A. and Audrey Jones Beck Collection
74.140

Floral Design:
Mrs. Louis Bishop
Alamo Heights Terrell Hills Garden Club

Materials:
African Lily *Agapanthus sp. cv.*
Bird-of-Paradise *Strelitzia reginae*
Carnation *Dianthus sp.*

The "discovery" of nonrepresentational art was Kandinsky's greatest achievement and contribution to the development of modern art. The artist's strong sensitivity to the reverberations of color and sound ultimately led him to nonrepresentational painting. He believed that art, through the orchestration of color and form, had a power comparable to that of music, which could lead to a mystical and religious culmination. In *Sketch 160 A*, the imagery of the fertile landscape and triumphant horseman at the top right may be read as a struggle between good and evil. The strong sense of movement and energy in *Sketch 160 A* and other canvases from this period showed that abstraction in art is the most expressive interpretation of our century.

DESIGNER'S INTERVIEW: The designer's interpretation of Kandinsky's *Sketch 160 A* was intended to express the variety of colors and lines used in the artist's canvas. A metal framework was constructed from which to suspend the brightly colored ball, picking up the bright tones in the painting. The cross-hatched mesh created from wires echoes the crossed lines in the canvas, while the sharp angles of the bird of paradise accentuated other shapes. The blue agapanthus at the base balances the arrangement as well as highlights the variety of blue tones in the painting.

THE QUAY, VENICE (VIRGIN WITHOUT CHILD)

MILWAUKEE ART MUSEUM
The Quay, Venice (Virgin Without Child), ca. 1921
Kees Van Dongen
Dutch, 1877-1968
Oil on canvas
Gift of Mrs. Harry Lynde Bradley
M 1973.610

Floral Design:
Mrs. David B. (Bonny) Martin
Garden Club of Memphis
Mrs. Theodore L. (Penny) Horne
Garden Club of Barrington

Materials:
False Bird-of-Paradise *Heliconia sp.*
Moth Orchid *Phalaenopsis sp.*

Kees Van Dongen is one of the most enigmatic and significant painters of the twentieth century. Painting in Paris after 1897, his work could be labeled as the offspring of Van Gogh and Matisse, in which a mixture of passionate expressionism and a relaxed, sensuous manner found perfect balance. Van Dongen was always a magnificent painter of women, best when he was least involved, when the woman became a symbol for femininity or mystery. Elongated bodies of fashionable women such as seen in *The Quay, Venice* have the mystical quality of a Jawlensky portrait.

AUTHOR'S COMMENTARY: In a tapered black container with red-orange heliconia, the elongated figure of the red-haired woman in the black dress is striking with the strong 90° angle emphasis. The single spray of philanopsis orchids jutting off to the right defines the white lights shimmering across the quay at night.

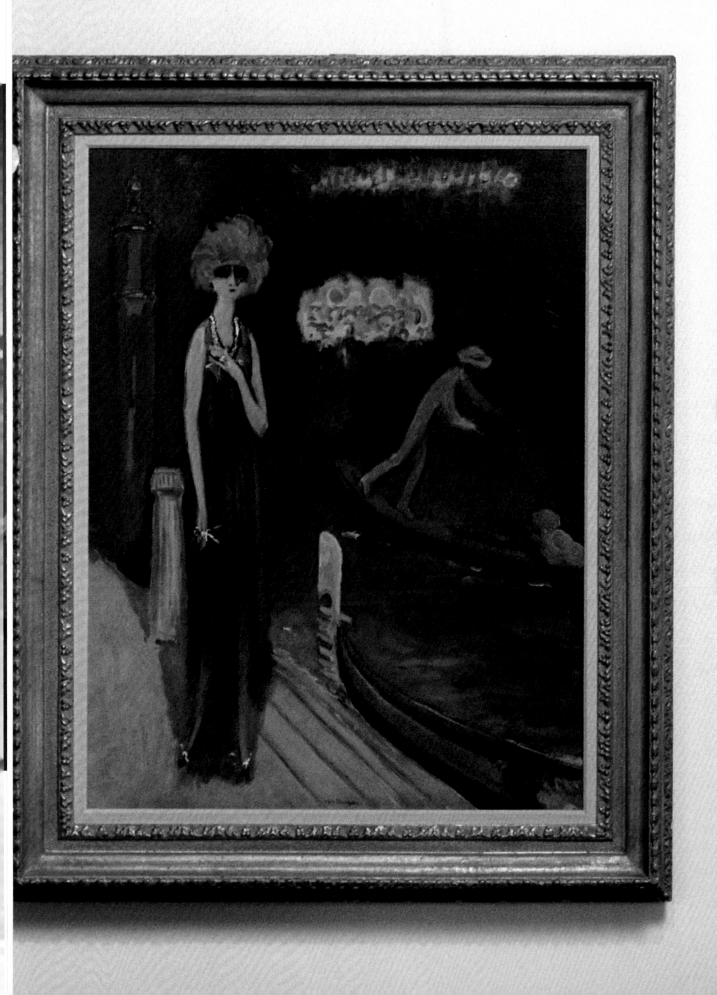

YIN SYNCHROMY NO. 3

SANTA BARBARA MUSEUM OF ART
Yin Synchromy No. 3, 1930
Stanton Macdonald-Wright
American, 1890-1973
Gift of Mrs. John D. Graham
1949.22.2

Floral Design:
Jane Patterson

Materials:

Yellow Calla Lily	*Zantedeschia elliottiana*
Delphinium	*Delphinium X elatum cv.*
Lily	*Lilium sp. cv.*
Rose	*Rosa X cv.*
Chrysanthemum	*Chrysanthemum X morifolium cv.*
Canna	*Canna X generalis cv.*
Shirley Poppy	*Papaver rhoeas*

Stanton Macdonald-Wright was one of the first American Abstract painters who in 1913-14 founded with Morgan Russell, the movement known as Synchromism which proclaimed color to be the basis of expression in painting. In his paintings, Macdonald-Wright created effects through rhythmic color forms and said that "color, in order to function significantly, must be used as an abstract medium." By 1920 his art was no longer avant-garde and had become a compromise between Synchromist abstraction and a traditional representational style. As seen in *Yin Synchromy No. 3,* he combined intense colors with the flowing lines of the sleeping figure.

DESIGNER'S INTERVIEW: The floral designer created a wonderful, vibrant arrangement, using the bright color palette of the artist. All of the flowers were picked from private gardens in Santa Barbara, except for the yellow calla lilies which she used to represent the flowers in the hands of the woman. The intense color contrasts of purple iris, orange and yellow poppies, and yellow roses made a vivid statement in harmony with the painting.

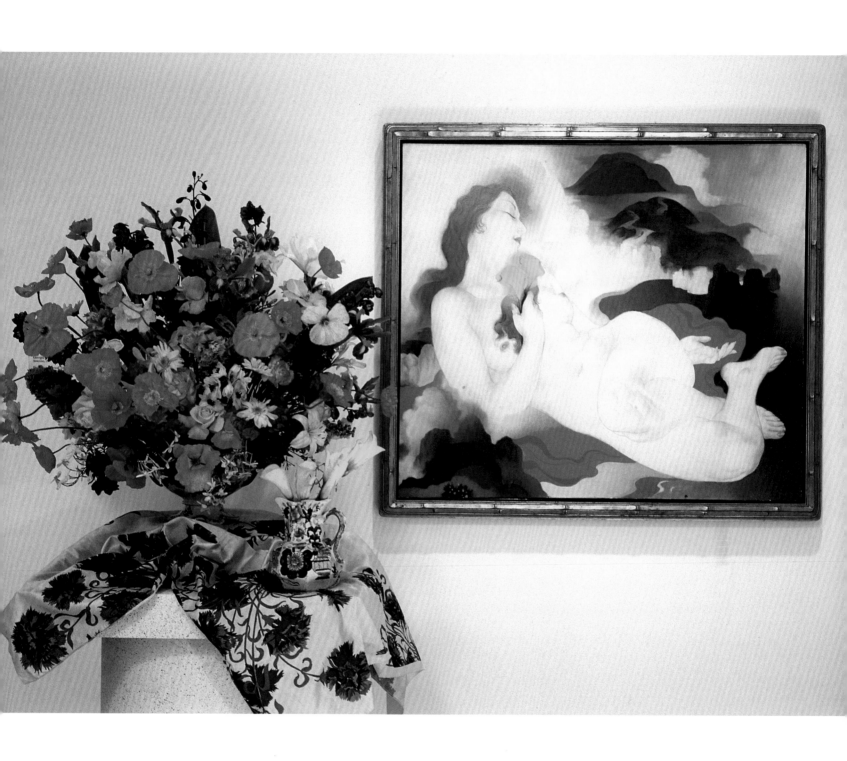

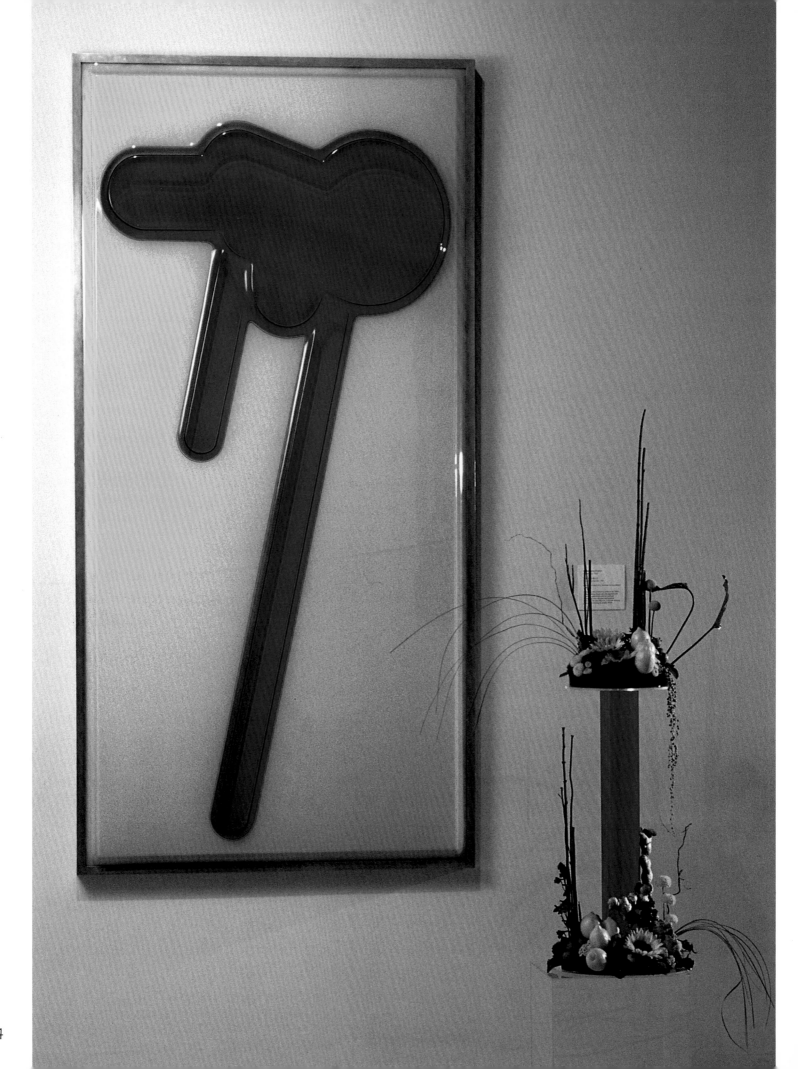

YELLOW-BLUE

SAN DIEGO MUSEUM OF ART
Yellow-Blue, 1965
Craig Kauffman
American, 1932
Vacu-formed acrylic
Gift of the Frederick R. Weisman Art Foundation
1990:132

Floral Design:
Ary Braun, AIFD
Golden Iris Florist

Materials:

Sunflower	*Helianthus annuus cv.*
Delphinium	*Delphinium X elatum cv.*
Orchid	*Orchidaceae*
Common Horsetail	*Equisetum hyemale*
Sphagnum Moss	*Sphagnum sp.*
String-of-Beads	*Senecio rowleyanus*
Common Ginger	*Zingiber officinale*
Bear Grass	*Xerophyllum tenax*
Lemon	*Citrus limon*
Salal	*Gaultheria shallon*
Brussels Sprout	*Brassica oleracea*

Like many other California artists in the 1960s, Craig Kauffman dispensed with pigment and canvas to experiment with the aesthetic potential of the new industrial and synthetic materials. His speciality was a vacuum-forming process for coloring his plastic reliefs.

Museum Wall Text

DESIGNER'S INTERVIEW: In my interpretation of *Yellow-Blue*, the plastic cylinder was filled with water and Windex™ to create the color of blue in the work of art. Ginger root was placed at the base of the arrangement and was carried part way up the side of the cylinder to connect the upper and lower portions of the floral design. The grasses, horsetail, and string-of-beads united this two-part arrangement. The bright yellow color in the acrylic was represented in the arrangement with lemons, sunflowers, and billy balls. The grasses and equisetum also connected the top and bottom of the arrangement, adding line and movement to the design.

GREAT HORNED OWL

1995 Fine Art and Flowers
WADSWORTH ATHENEUM
Hartford, Connecticut
Great Horned Owl
Paul Manship
American, 1885-1966
Bronze
Bequest of Honora C. Robertson
1979.249

Floral Design:
Mrs. Gerry Jenny
Pomeraug Valley Garden Club

Materials:

Tail flower	*Anthurium X cultorum cv.*
Spathe Flower	*Spathiphyllum X cv.*
Harry Lauder's Walking Stick	*Corylus avellana 'Contorta'*
Palm	*Arecaceae*

Early in the twentieth century, the most brilliant sculptor who worked in the academic tradition was Paul Manship. His work offered a compromise between the traditional historicism and the new tendencies toward abstraction. Manship, inspired by the decorative patterns and rhythmic stylizations of the art from the ancient Middle East, created sculptures such as *Great Horned Owl*. The stylized patterning of the owl's feathers and the clean, simple lines of the body depict Manship's skill with simplification and stylization of natural forms. Manship's bronzes are notable for the exceptional beauty of their craftsmanship and their exquisite surfaces.

AUTHOR'S COMMENTARY: In this unusual interpretive arrangement, Gerry Jenny placed her elongated floral design directly beneath the owl, creating a sense of a continuous vertical flow between the two pieces. The strong, compact body of the owl is interpreted with solid, almost sculptural floral materials. The patina of the bronze owl is felt in the translucent surface of the anthurium while the twisting Harry Lauder's Walking Stick adds movement and interest to the composition.

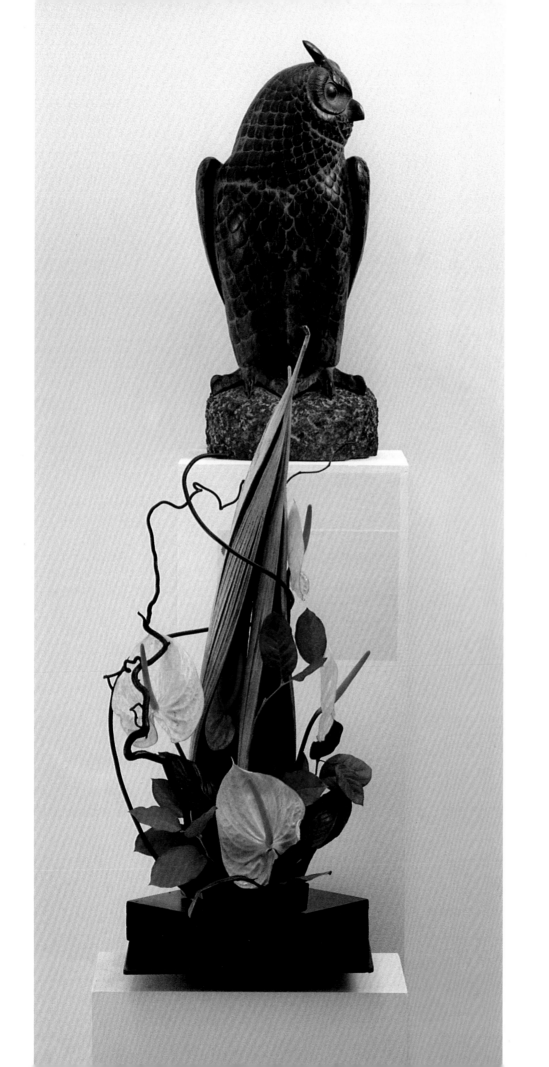

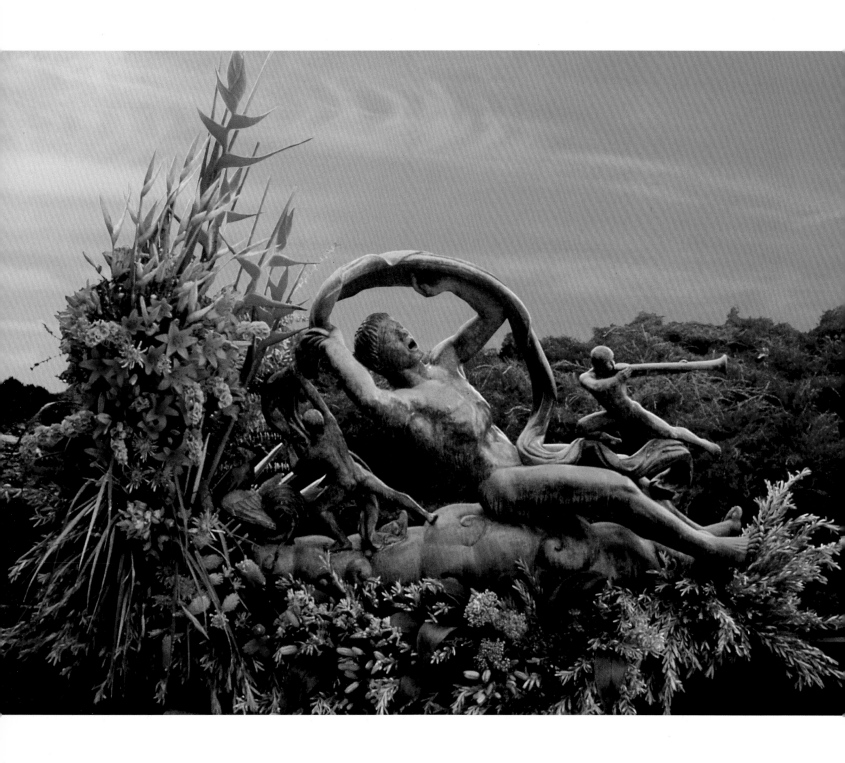

THE MOODS OF TIME: MORNING

UNIVERSITY OF UTAH MUSEUM OF FINE ARTS
The Moods of Time: Morning, 1938
Paul Manship, American, 1885-1966
Bronze sculpture
Gift of the Marriner S. Eccles Foundation
for the Marriner S. Eccles Masterwork Collection
1983.005

Floral Design:
Rob McFarland, Jerry Stanger
Ward and Child – The Garden Store

Materials:

False-Bird-of-Paradise	*Heliconia sp.*
Lily	*Lilium sp.*
Bells-of-Ireland	*Moluccella laevis*
Chrysanthemum	*Chrysanthemum X morifolium cv.*
Variegated Sweet Iris	*Iris pallida 'Albo-variegata'*
Blue Lyme Grass	*Elymus arenarius 'Glauca'*
Cymbidium Orchid	*Cymbidium sp.*
Protea (Winter Sunshine)	*Protea sp.*
Silver Dollar Gum	*Eucalyptus polyanthemos*
Red Hot Poker	*Kniphofia uvari*
Gladiolus	*Gladiolus X hortulanus cv.*
Star-of-Bethlehem	*Ornithogalum arabicum*
Showy Stonecrop	*Sedum spectabile*
Ti	*Cordyline terminalis*
St. John's Wort	*Hypericum sp.*

Paul Manship, an American sculptor, was born in St. Paul, Minnesota. His first one-man exhibition was with the Architectural League of New York in 1912, and he had a retrospective exhibition at the Smithsonian Institution in 1958. He was mainly known for portraits and mythological groups executed in a highly competent academic style.

DESIGNERS' COMMENTARY: The sculpture has a very fluid, nautical feeling. We used the foliage as a medium for water cradling the awakening man. The color is introduced as buds, waiting like the man to be awakened by the sunrise. As the morning progresses, the flowers become more open, more intense, ending in an explosion of color and form impossible to sleep through!

BABOON AND YOUNG

MINNEAPOLIS INSTITUTE OF ARTS
Baboon and Young, 1951
Pablo Picasso
Spanish, 1881-1973
Bronze
Gift of Mr. and Mrs. John Cowles
55.45

Floral Design:
Nancy Allison
Ramblewood Garden Club
Bloomington Affiliated Garden Club

Materials:

Aspidistra foliage	*Aspidistra elatior cv.*
Pink Ming Protea	*Protea sp.*
Grape Vine	*Vitis sp.*

Pablo Picasso, Spanish artist and leader of the´Ecole de Paris, dominated the development of the visual arts during most of the first half of the twentieth century. His versatility, technical brilliance, and imaginative depth probably have not been surpassed. Although a master of the classical tradition, Picasso's influence has been to strengthen the conception of art as an emotional medium with dynamic power and vitality. Picasso's interest in sculpture emerged during the 1930s, demonstrating, as in his painting, his amazing imagination. He approached sculpture without preconception. As he said, "One should be able to take a bit of wood and find it's a bird."

AUTHOR'S COMMENTARY: In this delightful interpretation of Picasso's *Baboon and Young*, the designer has used grape vine to represent the round sculpture, and protea the bronze mother and child baboons. Her contemporary container with its circular lip is appropriate with Picasso's abstract sculpture.

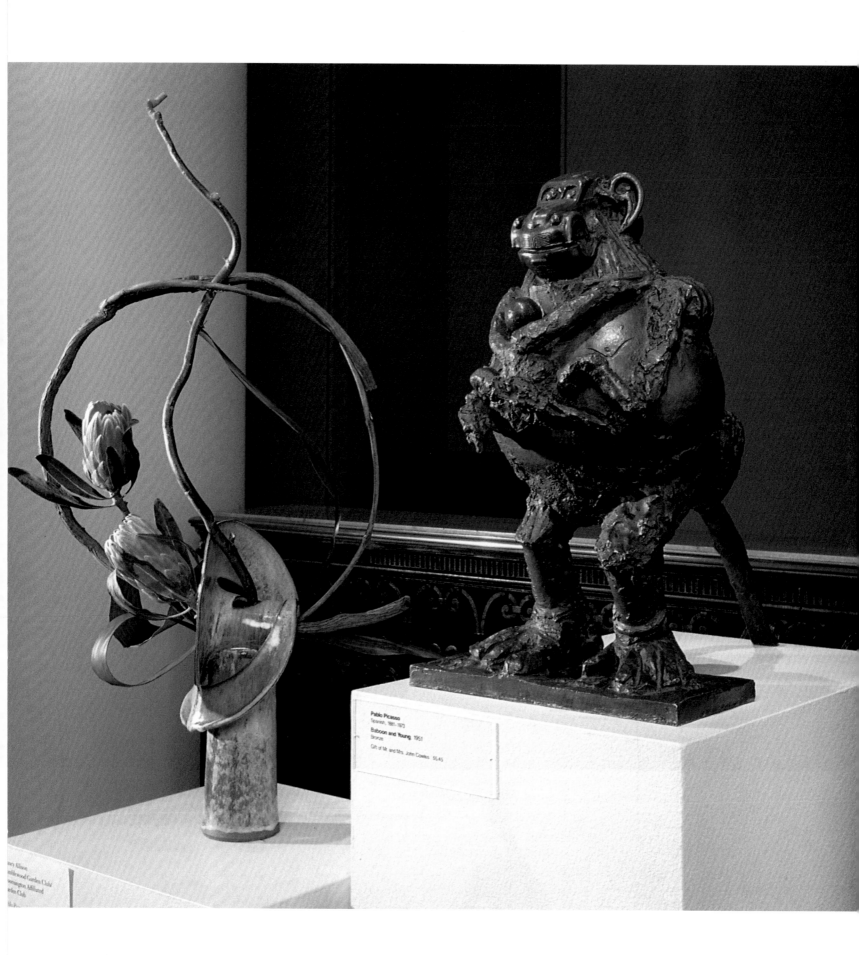

Pablo Picasso
Spanish, 1881–1973

Baboon and Young, 1951
Bronze

Gift of Mr. and Mrs. John Cowles 55.45

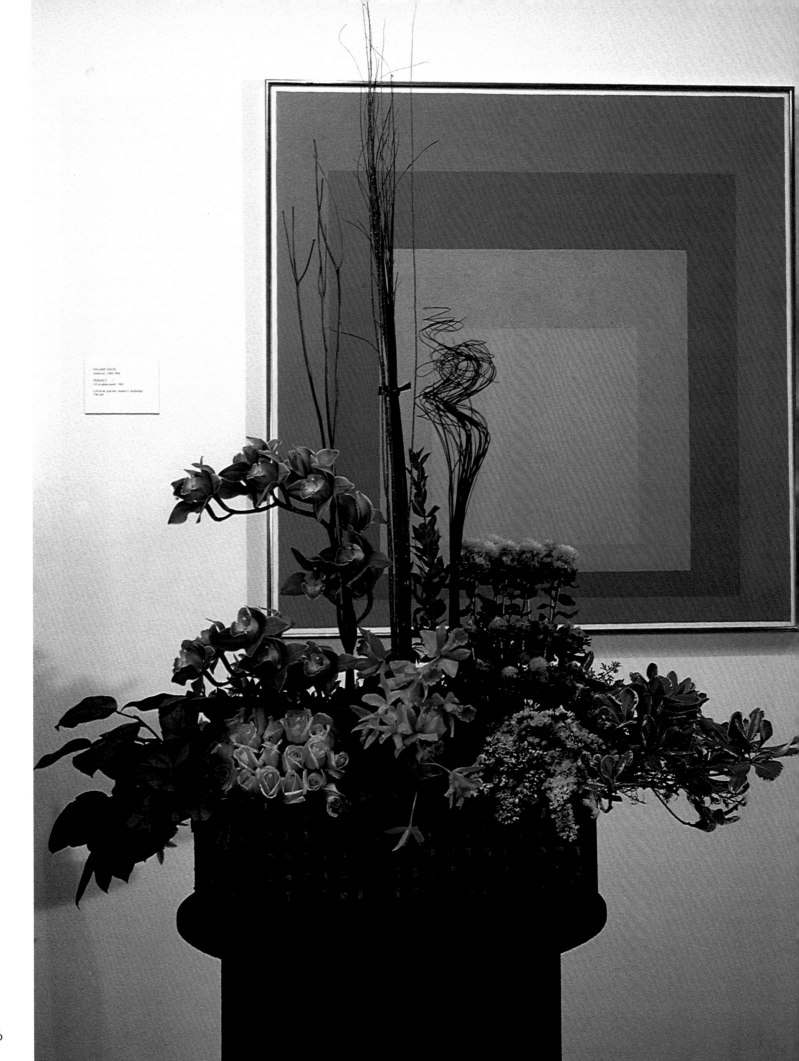

HOMAGE TO THE SQUARE: ON DRY GROUND

SAN DIEGO MUSEUM OF ART
Homage to the Square: On Dry Ground, 1963
Josef Albers
American (born Germany), 1888-1976
Oil on masonite
Gift of Mr. and Mrs. Norton S. Walbridge
1991:8

Floral Design:
Leesun Cu Staley
Village Garden Club of La Jolla

Materials:

Cymbidium Orchid	*Cymbidium sp.*
Chinese Lantern	*Physalis alkekengi*
Rattlesnake Grass	*Briza maxima*
Common Horsetail	*Equisetum hyemale*
Variegated Pittosporum	*Pittosporum tobira 'Variegata''*
Salal	*Gaultheria shallon*

During the summer of 1949, Albers began a series of four-colored Homage paintings which used nested squares, symmetrically set within each other in an austerely simplified four-color palette. The horizontal axis of the nested squares is symmetrical, while the vertical axis is asymmetrical, giving a vitality to the pattern. Albers spent his long life in the study of form and color. His design in the Homage series (1949-57) of the nested square holds the form so rigidly that it becomes of secondary meaning to his exploration of color. Albers stated that any group of colors could have an exciting relationship. He never mixed colors, preferring to work with tube color, applying it directly to the masonite panel after seven coats of primer. He painted a smooth surface, eliminating texture.

DESIGNER'S INTERVIEW: The importance of the colors used in Alber's painting sent the designer on a search for the appropriate floral materials. The cymbidium orchid was used to represent the brown tones, and the Chinese lantern the orange color. The basket was lined with dried lotus leaves, adding a tan hue through the open lattice-weave. The beauty of her floral art added a handsome new dimension to the work of art by adding new textures and shapes. The colors of the painting remind one of the desert; perhaps that is why this Homage painting was titled *On Dry Ground.*

UNDER PRESSURE

MILWAUKEE ART MUSEUM
Under Pressure, 1973
Charles Hinman
American, 1932
Acrylic on canvas
Gift of Mrs. Harry Lynde Bradley
M 1975.141

Floral Design:
Elaine Burke
Kettle Moraine Garden Club

Materials:

Parrot's Flower	*Heliconia psittacorum*
Palmetto Palm	*Sabal sp.*
Cattail	*Typha sp.*
New Zealand Flax	*Phormium tenax*

Charles Hinman, an American painter born in 1932 in Syracuse, New York, has been a professional painter since 1966. He has exhibited in a number of selected group and individual shows. Hinman was awarded lst prize at the Nagoka Museum, Japan in 1965.

AUTHOR'S COMMENTARY: The three-dimensional white container with red heliconia and clipped green palm leaves is so well constructed it seems part of the actual painting itself. Even the cattail is shaped into a geometric design.

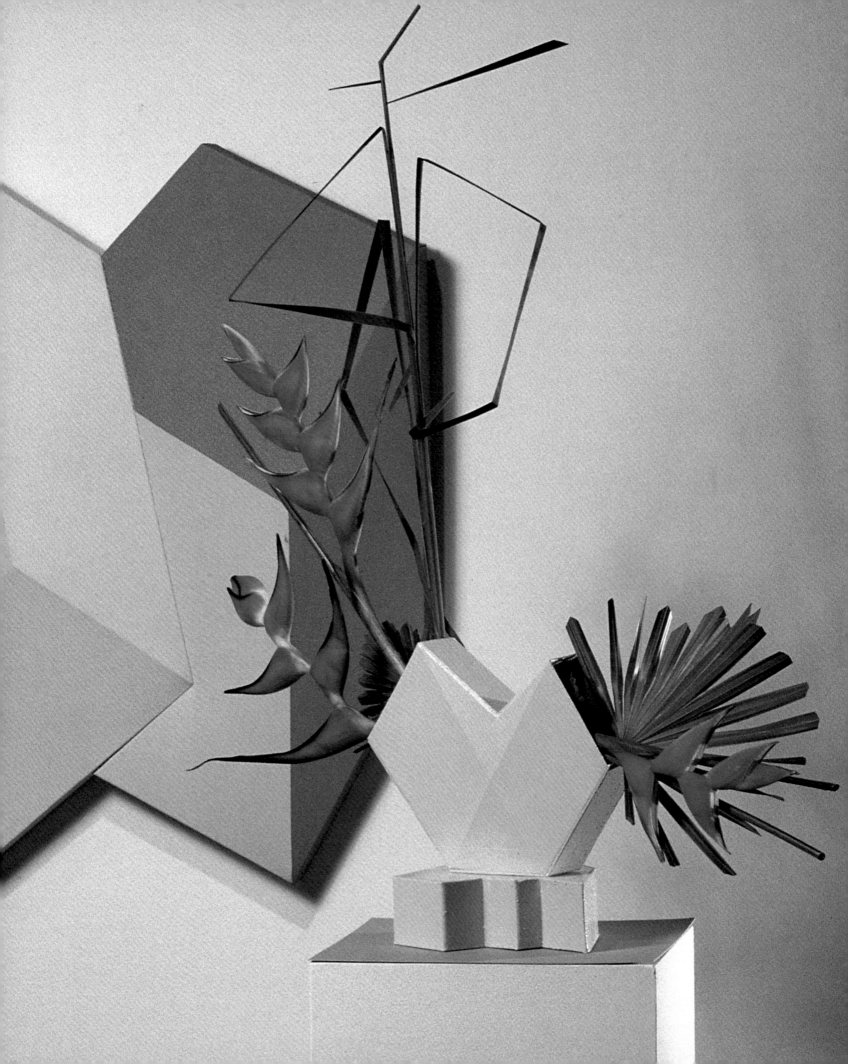

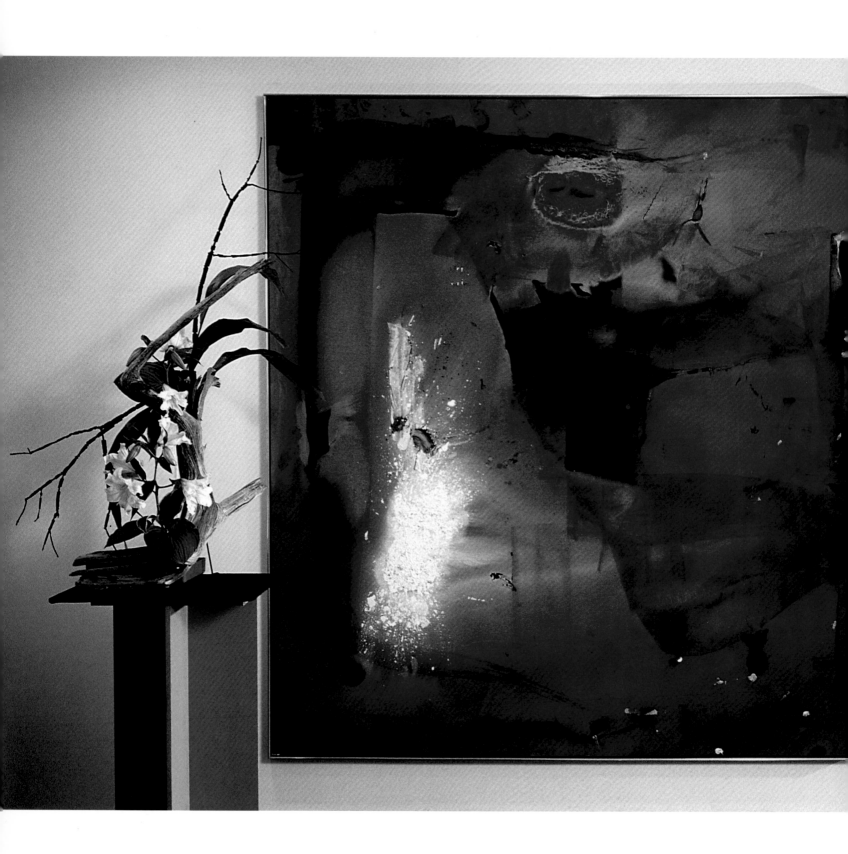

SEER

MEMORIAL ART GALLERY OF THE
UNIVERSITY OF ROCHESTER
Seer, 1980
Helen Frankenthaler
American, 1928
Acrylic on canvas
Gift of the Women's Council on the occasion of
the Council's 40th anniversary

Floral Design:
Dale Fennie
Allyn's Creek Garden Club
Garden Lovers of Brighton

Materials:

Winged Euonymus	*Euonymus alatus*
Casablanca Lily	*Lilium X 'Casablanca'*
Hosta	*Hosta sp. cv.*
Ti	*Cordyline terminalis cv.*

Helen Frankenthaler's *Seer* is representative of her color-field paintings. This internationally recognized American artist depicts an explosion of white on a green and black background with acrylic color stained into raw canvas. Frankenthaler uses flat planes of opaque color and obscure forms against which the brilliant light of the *Seer* is dramatically brought into focus.

DESIGNER'S INTERVIEW: The designer saw large forms and an exciting yet peaceful embracing figure with outstretched arms. Her arrangement included the white lilies representing the *Seer*, and a variety of open and branching hosta and ti leaves, giving the viewer a sense of reaching out toward the light.

DABS

SAN DIEGO MUSEUM OF ART
DABS, 1982
Peter Alexander, born 1939
Acrylic and fabric collage on velvet, 1982
Gift of the Frederick R. Weisman Art Foundation
1990:112

Floral Design:
Lenore Hughes
Village Garden Club of La Jolly

Materials:

Baby's Breath	*Gypsophilia paniculata*
Gay-feather	*Liatris spicata*
Pincushion Flower	*Lecospermum sp.*
Black Cohosh	*Cimicifuga racemosa*
Statice	*Limonium sp.*
Billy Balls	
Grass	*Miscanthus*

In the early 1980s, inspired by a nighttime sea voyage on a fishing vessel off the California coast where the sea was fluorescent with tiny organisms and squid attracted by an arc of bright light off the boat, Peter Alexander created a series of acrylic and fabric paintings on velvet. In this illusionist art, the myriad forms are non-representational. They simply exist and interact in the inky darkness of the night ocean, leaving interpretation to the viewer. The paintings are not wholly paintings, as many of the forms are cut pieces of material sewn to the black, unstretched velvet surface.

DESIGNER'S INTERVIEW: Lenore Hughes, a watercolor and collage artist, interpreted *DABS* as a painting of fireworks. She used materials from her studio to create the three fire-work vases; watercolor tubes which held paper, stickers, stencils, and labels. These painted cardboard tubes were filled with cylinders to hold water. Gypsophilia represented the explosion of white lights, yellow Billy balls and the purple liatris in the left tube reflected the rocketlike streaks in the upper corner of the painting on velvet. Though Peter Alexander depicted ocean forms in his work of art, *DABS*, the floral designer interpreted his work as a nighttime celestial experience.

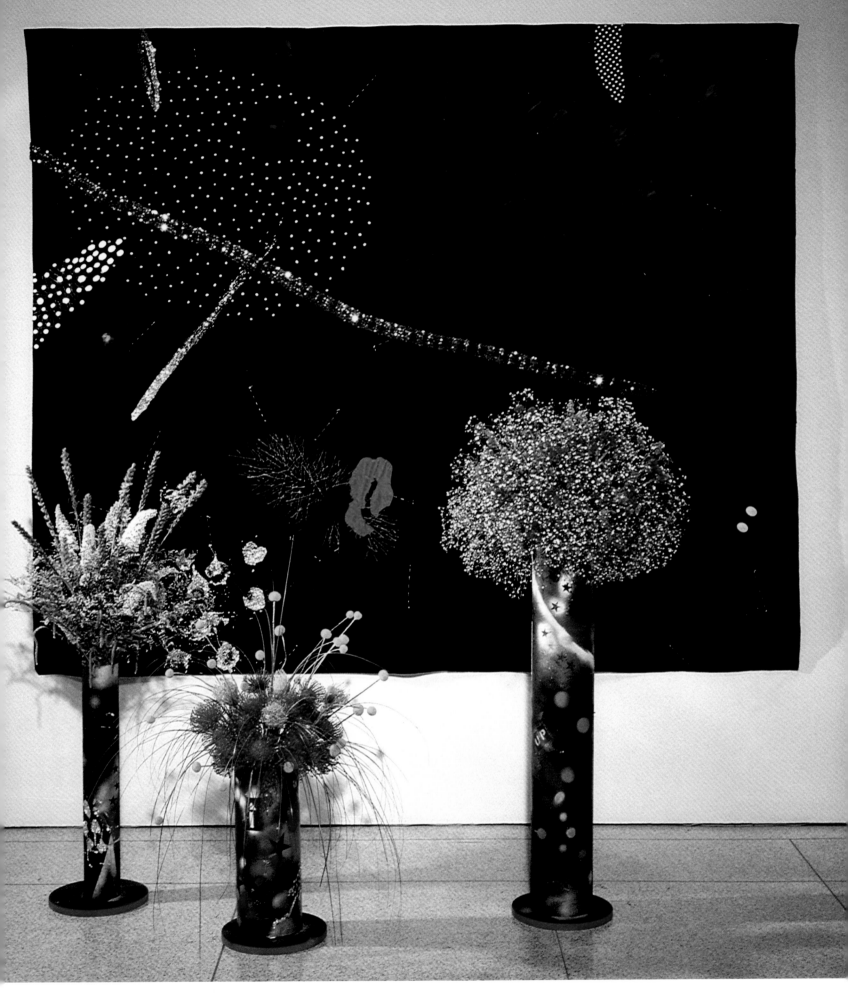

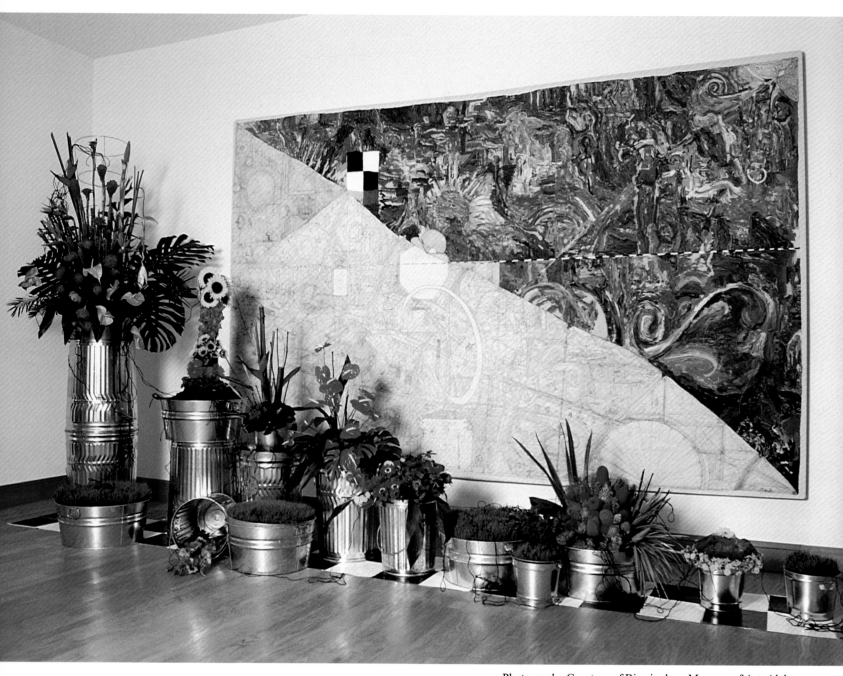

Photography Courtesy of Birmingham Museum of Art, Alabama

REMEDIAL ARCHAEOLOGY AND THE LIKE

BIRMINGHAM MUSEUM OF ART
Remedial Archaeology and the Like, 1986
William T. Wiley
American, 1937
Acrylic and graphite on canvas
Museum purchase

Floral Design:
Sybil Sylvester
Wildflower

Materials:

Grass	*Poaceae*
Sunflower	*Helianthus annus*
Bird-of-Paradise	*Strelitzia reginae*
Split-leaf Philodendron	*Monstera deliciosa*
Torch Ginger	*Nicolaia elatior*
Tail-flower	*Anthurium x cultorum cv.*
Anemone	*Anemone sp.*
Transvaal Daisy	*Gerbera jamesonii cv.*

William T. Wiley's large-scale, semi-abstract painting vividly displays his strong, incisive graphic quality. Bursts of intermingling bright colors and Wiley's use of abstract symbols such as the tic-tac-toe, the black and white surveyor's strip, and the figure-eight infinity symbol are characteristic of his works. The bottom triangle symbolizes the underpinnings or archaeological basis of the upper painting which explodes into vivid color and design. Wiley's art has been called "loose and wacky." The physical perimeters of the painting are held in place by the 'ragged edge' known as Wiley's visual signature.

DESIGNER'S COMMENTARY: While interpreting this complex painting, I found myself drawn to Wiley's layers of graphic drawings underneath the colorful art. I envision the years of doodling and sketching that I see as the building blocks that artists use to develop their talent. Therefore, as in archaeology, one digs through layers of earth to find the treasures of the past, we can look through the layers of paint and see all the drawings of everyday items and events. From this interpretation I chose to use galvanized containers and grass to represent everyday items and bold, brilliant, unusual colors and flowers to complement the painting.

MAX BECKMAN'S COLORS

DETROIT INSTITUTE OF ARTS
Max Beckman's Colors, 1987
Arman
American, 1928
Acrylic and paintbrush on canvas
Founders Society Purchase
W. Hawkins Perry Fund
1933.34

Floral Design:
Dorothy Mengden
Greater Detroit Flower Arrangers Guild
Garden Club of Dearborn
Grosse Pointe Shores Garden Club

Materials:
Statice *Limonium sp.*

Max Beckman (1884-1950) became an Expressionist painter after living through the horrors of World War I. He created complex scenes depicting in powerful images his despair at modern civilization, painting in strong colors, full of subjective symbolism. In a lecture delivered in London in July of 1938, Beckman said, "In my opinion all important things in art since Ur . . . have always originated from the deepest feeling about the mystery of Being. Self-realization is the urge of all objective spirits. It is this self for which I am searching in my life and in my art." In Arman's unusual tribute to Max Beckman, he presents a painting which is full of real paint brushes sweeping bold colors onto the canvas.

AUTHOR'S COMMENTARY: The designer focused on the painter's equipment and created her arrangement using miniature paintbrushes revolving around a ball of blue statice and a spilled container of yellow paint beneath a small stepladder.

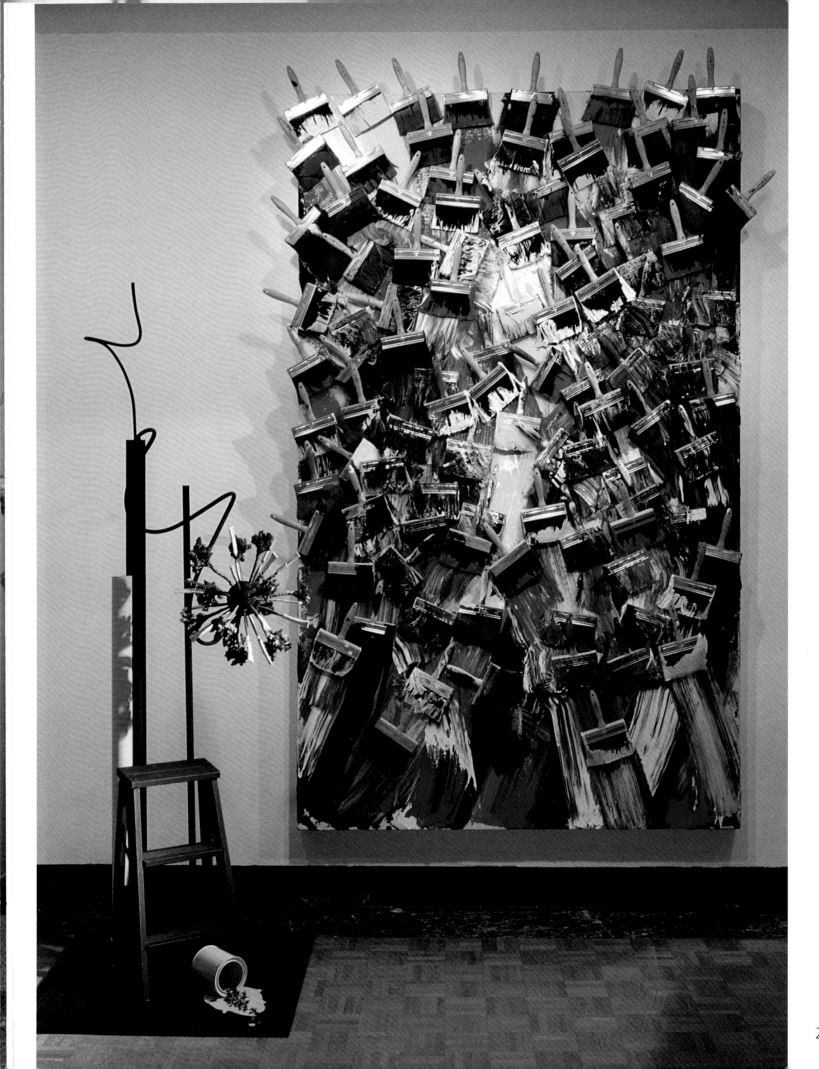

PART TWO
ART IN BLOOM
BEYOND THE MUSEUM

Creating *Art in Bloom* At Home

F lowers, a beautiful expression of nature's art, bring warmth, color, and freshness to any setting. A small vase of violets, brilliantly colored parrot tulips, or fragrant lilies can become the focal point of any room. And for special occasions, it would be hard to imagine any celebration without flowers, from an elaborate wedding to an intimate dinner for friends.

We usually select flowers which will complement the colors or mood of a room, or will embellish a particular theme or season. We visualize our homes as a composite of architecture, furniture design, color, decorating style, lighting, and space. It is the combined effect of these elements to which we respond.

We can create *Art In Bloom* at home, following the same principal considerations the floral designers use in creating arrangements for museum art. By selecting an art object to highlight, and then arranging flowers to complement that art, we add a new, dramatic dimension to our own environment.

What work of art in your home could become an *Art In Bloom* focal point? Select a work of art you feel would be enhanced by a floral arrangement. Plan for adequate space and lighting to show the display you design to its best advantage. You will probably want to place this *Art In Bloom* exhibit in a major room in your home where it will be enjoyed by the most people. Envision how flowers might interpret the work of art and how this new composition would enhance the room overall.

Carefully consider and study all aspects of the work of art. If it is a painting you choose to interpret, what impresses you the most? Is it the subject matter, the colors used by the artist, or the overall mood it creates? If it is a landscape, does it portray a close, intimate view of nature, or a grand sweeping scene? The season portrayed in the landscape dramatically affects the color palette of the artist and the mood it produces.

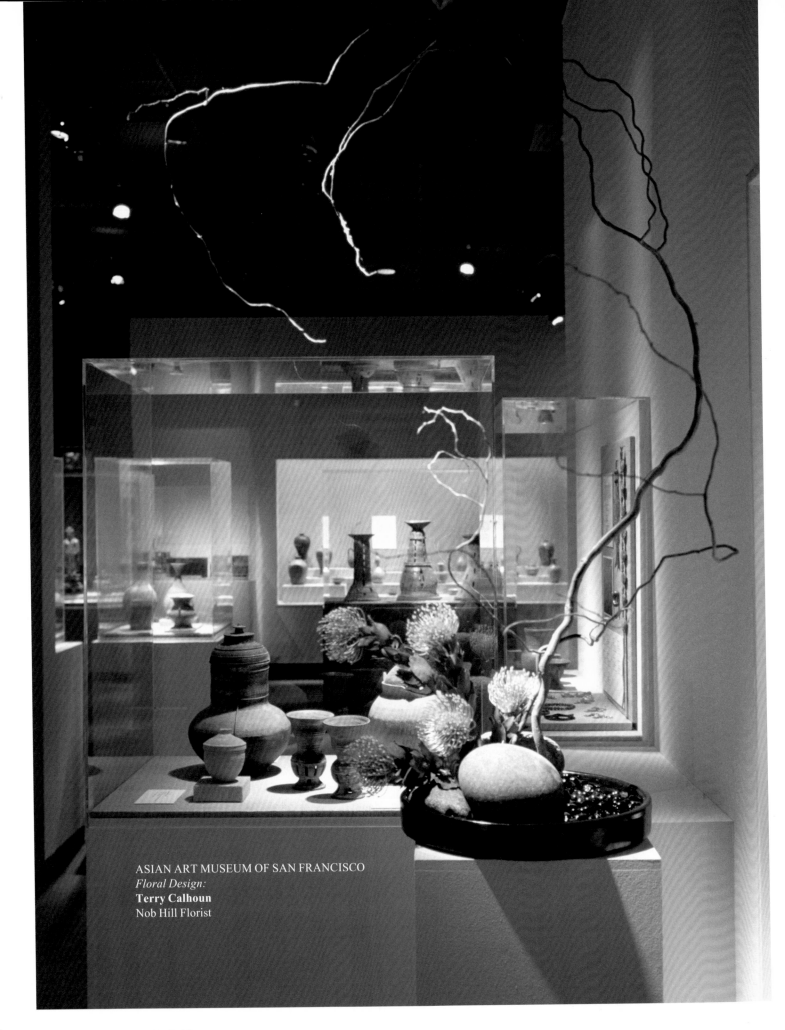

ASIAN ART MUSEUM OF SAN FRANCISCO
Floral Design:
Terry Calhoun
Nob Hill Florist

As important as color and scale are to the success of your efforts, the use of line or flow of the floral materials is critical. If the painting has a Victorian mood, then your arrangement would be effective with a massing of floral materials (page 166) where there is no visible space between the flowers, in keeping with the abundance of blossoms so typical of that period.

In contrast to the massed bouquet, restrained arrangements with a minimal use of flowers and foliage are created in Ikebana or Asian floral design. Sweeping lines are achieved by careful placment of branched materials. The spaces between the floral material are considered to be as important as the flowers, creating an effect of quiet beauty that can be used with both western and eastern art. In most instances, the carefully designed, simple arrangements are the most effective examples of *Art In Bloom.* In general, large, closely massed floral arrangements should be reserved to beautify interiors of an entire room, but not used with a specific work of art. It cannot be said too often that the art must never be overwhelmed by the flowers. The art and floral elements must complement and enhance the beauty of each other.

If you are unsatisfied with the effect you have created, start over. "Genius is three-quarters hard work." It is usually very difficult to "fix" an arrangement that is not quite right. Starting over completely is sometimes necessary and may well produce a fresh approach you hadn't considered the first time you tried the *Art In Bloom* interpretation.

Keeping these floral arranging tips in mind will help you be successful in your at-home *Art In Bloom* creations.

A few basic rules of flower arranging should be mentioned.

- **If the flowers are from a garden**, pick them in the cool morning or in the evening when the most moisture possible has been absorbed by the plant into its stems. Whether from the florist or garden, place the flowers with their freshly cut stems in lukewarm water up to the throats of the blossoms, and leave them to "condition" or absorb as much moisture as possible for a few hours before you arrange them.

- **Woody-stemmed materials** such as lilacs or forsythia should have the stems bruised or smashed at the ends to help absorb water. Roses benefit from a gentle scraping of parts of the stems.

An outstanding example of *Art In Bloom* was created by designer Carol McDonald at the Milwaukee Art Museum. The painting she interpreted was *Hour of Rest* by Hovsep T. Pushman before 1915, (M 1915.1) Consider the elements just discussed in analyzing the effectiveness of this exhibit.

On studying this painting, the subject matter of the sleeping, elegant lady first catches the viewer's eye. The designer thought of her in this way, " Pure boredom just may have overcome this upper-class American lady. Before 1915 she certainly could not jet to Milwaukee, Philadelphia, or Chelsea to a flower show. Merely dressing for the day must have been exhausting. Perhaps she has just finished a flower arrangement! In interpreting this painting, my intention was to set the mood, one of relaxed elegance." To the designer, the mood and subject were as critical to her floral arrangement as the mood and subject were to the painter.

To create the mood of relaxed elegance, the floral materials needed to be classical and the design arranged to gracefully cascade from a container which would be tall enough for the flowers to fall downward. The clean lines of the beautiful blue ceramic vase met this requirement as well as picked up the wonderful blue shades of the woman's gown. The arrangement falls in a sweeping movement down to the rose petals scattered on the stand, just as the figure of the sleeping woman sweeps down into the corner of the painting with her long gown and graceful shawl.

Use the color palette of the artwork to guide your floral choices.

The color palette of the painting is beautifully coordinated with the floral materials as seen in the lime green hydrangeas and the varieties of yellow-green foliage. The woman's peach-colored flesh tones are highlighted by the soft peach tones of the roses. The designer's color sense was so perfect, one might suspect that the painter himself had painted the floral material!

The large-scale painting was appropriately represented with the long lines of the flowers and vase. Carol McDonald considered all the essential elements of a successful *Art In Bloom* exhibit; subject, mood, color, floral materials, choice of container, scale, and design.

Large-scale interior plans invite *Art In Bloom* to express your taste.

Expanding *Art In Bloom* to a larger scale portrays the concept that art juxtaposed with well-designed flowers markedly enhances the spaces in which we live.

In a Utah home, fabrics and draperies were selected to reflect the rich earth tones in the large rock fireplace and the redwood ceilings. The painting above the mantle, *Reflections, Landscape with Pond* by Ovanes Berberian, displays a myriad of vibrant fall colors in trees reflected in a dark pond. The large hand-carved mantle with the horizontal painting hanging above it requires a horizontal floral arrangement. A series of containers in close touch to one another were placed along the mantle. A selection of flowers in orange, yellow, and rust hues were arranged below the painting, using the colors of the artist's palette. A variety of sizes and shapes were used in the floral selection. The single white rose in the foreground was placed on the ladies writing desk. This touch of white moves the viewer's focus to the marble sculpture, *Nursing Mother* by Avard Fairbanks, as well as to the young girl in the white pinafore in the painting on the easel, *Under the Sunflowers* by Robert Duncan.

In an interior designed by Colleen Horne, the view from the romantic dinner for two in the foyer extends through the living room to the painting over the handcrafted mantle. Art surrounds the elegant table setting on all sides. In the foreground is a bronze bust of *Dr. Lyman Horne*, sculpted by his son, Dr. Jonathan Horne. The mantle with antique Chinese porcelain is highlighted by the painting *Texas Bluebells* by William Slaughter. The white garden roses placed on the candles and the yellow calla lilies on the living room coffee table add depth and richness to the scene. Without the flowers and art this setting would lose much of its sophisticated charm.

A casual private setting features "Strawberries For One" by designer Colleen Horne, seen here in the evening on a redwood deck with a charming bronze, *Flower Girls*, by Utah sculptor Gary Price. These two sisters holding bouquets are surrounded by large hanging baskets of summer flowers. Arranged on the table beside the inviting chaise lounge are red strawberries and a glass of wine. On the small table, a bronze sculpture by Dr. Jonathan Horne, entitled *The Way*, depicts a baby grasping an adult's finger to emphasize the nurturing theme of childhood. To brighten the scene, a garden bouquet of white shasta daisies rests on the bench beside the sculpture. The architecture of the wooden deck, the bronze sculptures, and the flowers are all important elements of the total effect. What an inviting setting for a relaxed summer evening!

Title unknown, painted by Koros

For all of us, dining is a setting where art and flowers can be successfully interrelated to enhance the pleasure of any meal. In a formal dining room, large- scale floral arrangements were used to set off the massive, dark antique Chinese chest. These tall arrangements rising well above the table allow for conversation among the guests at dinner without obscuring eye contact. As the table settings were white and gold, white floral materials were used rather than introducing competing colors which would have diminished the effectiveness of the unity within the harmony of the chosen elements. Paintings on easels and an Oriental carpet provided the only color in the room.

The same dining room, under the direction of interior designer George P. Miller, becomes an Oriental setting by separating the chests, adding an

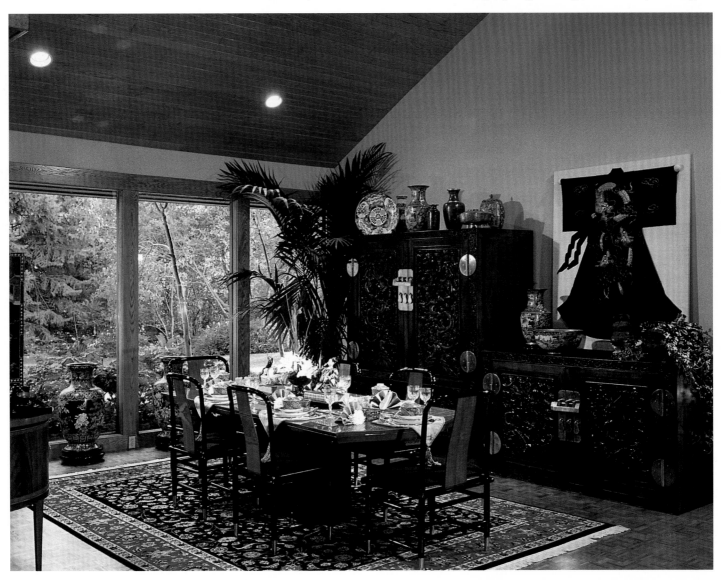

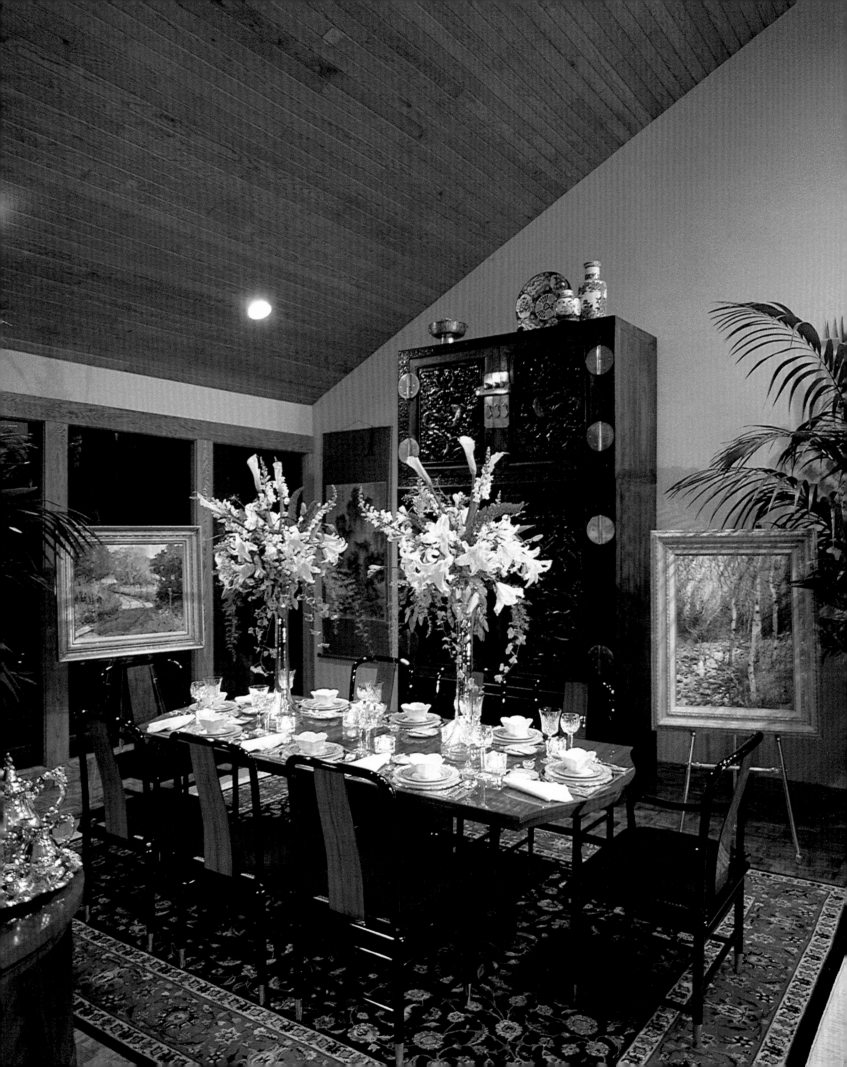

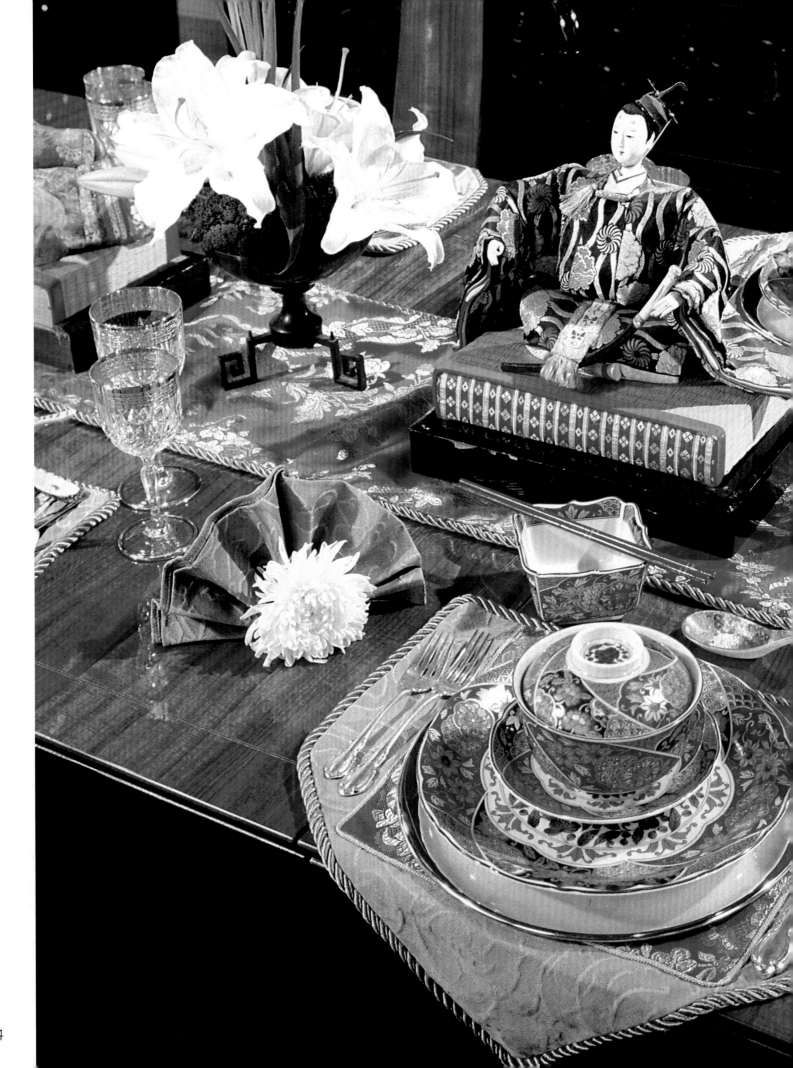

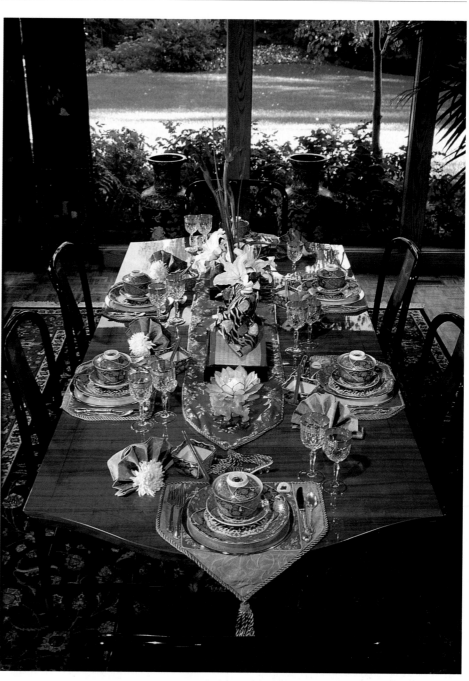

antique Chinese kimono, screens, and a variety of Oriental vases, bronzes, and porcelains. The table was set with Oriental dishes and place settings. A fresh chrysanthemum was tucked in each folded napkin; antique Japanese dolls, and a simple floral arrangement of white calla lilies and purple iris were used. In this instance, the art was the major component of the room.

PART THREE
PHOTOGRAPHER AND SOURCES

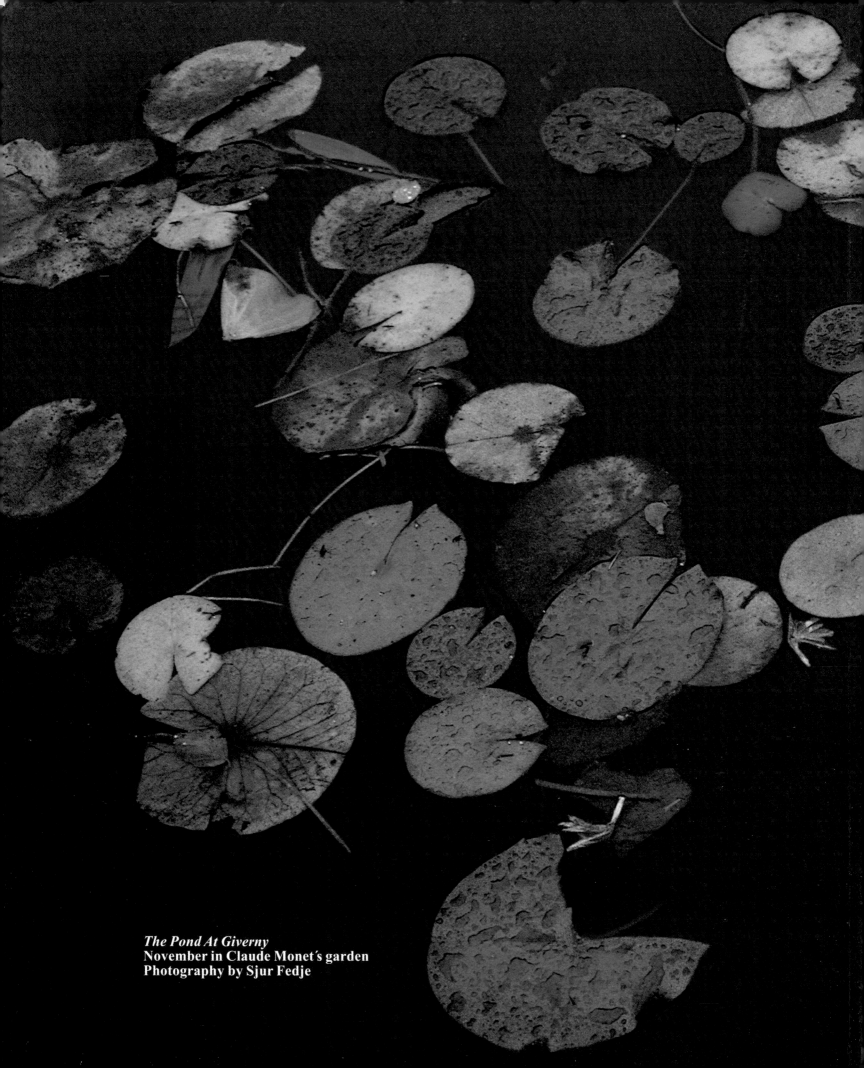

The Pond At Giverny
November in Claude Monet´s garden
Photography by Sjur Fedje